Voices of America

Growing Up On A
Minnesota Farm

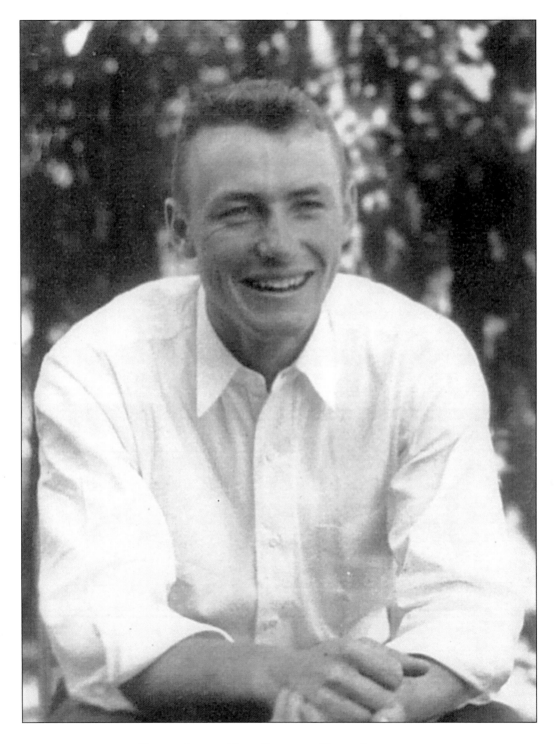

MICHAEL COTTER—THIRD GENERATION FARMER STORYTELLER.

Voices of America

Growing Up On A Minnesota Farm

Michael Cotter and Beverly Jackson

ARCADIA
PUBLISHING

Published by Arcadia Publishing
Charleston, South Carolina

Printed in the United States of America

Library of Congress Catalog Card Number: 2001092296

For all general information contact Arcadia Publishing at:
Telephone 843-853-2070
Fax 843-853-0044
E-mail sales@arcadiapublishing.com
For customer service and orders:
Toll-Free 1-888-313-2665

Visit us on the Internet at www.arcadiapublishing.com

CONTENTS

ACKNOWLEDGMENTS

When an oral history is written, the memories belong to the storyteller. In this book, Michael Cotter shares with us his experiences of growing up on a farm that his grandfather Maurice Cotter purchased from the railroad in 1876. His father Richard was born that same year, and he was 55 years old when Michael was born in 1931. Because of the age difference, their theories of farming were vastly different, but Michael understood and appreciated the history that allowed him to be a part of that century farm. Our thanks go to the generations that made these memories possible. Many of the photographs that we needed to define Michael's various experiences were gleaned from the collections of the Freeborn County Historical Museum archives and the Mower County Historical Society. We appreciate the help of Linda Evenson of the FCHM library and Shirley DeYoung from MCHS. Other photos came from the personal collections of neighbors: Harlan Boe, Paul and Mary VanPelt, Dennis Nelson, and Joe Srp. The Cotter family archives are small because of a house fire, but we were able to find a number of photos that define the personality of the Cotter farm. Thank you to the family members who shared their own collections, and to Tom Cotter, photographer, and the fourth generation on the farm.

INTRODUCTION

The cycle of a Minnesota farm is the cycle of seasons, and so it is with the seasons of all life:

Spring—planting and new birth,
Summer—nurturing,
Fall—harvest and thanksgiving,
Winter—rest, routine chores, and then preparation for the new spring.

Michael Cotter is the third generation on a farm just west of Austin in Southern Minnesota. His grandfather bought the land from the railroad, and with his team of oxen, was the first to break that prairie sod. In 1876 Michael's father was born, and today Michael's son is living on that farm. Hopefully, Cotter generations years to come will still call that land home, and continue to nurture it just as it has been for more than 125 years.

The stories of the Cotter farm and its neighboring communities, from the 1930s to the 1970s, provide us with an insight into the history of farming in Southern Minnesota. This rolling prairie land, with its occasional oak openings, was developed into some of the most productive farm land in the world thanks to the sheer determination and backbreaking labor of the Europeans who settled this area in the late 19th and early 20th centuries. In *Growing Up On A Minnesota Farm*, this history is shared as seen through the eyes of the grandson of one of the first settlers.

Michael was born in the farmhouse in the spring, April 13, 1931. He is the eighth and the youngest child of an Irish Catholic family. The future of that farm would become his future, and he would see it grow from a small family farm of 320 acres to almost 1,000. His earliest memories are of the spring calves cavorting in the aisles of the barn, and of the Depression-era hobos who drifted in wanting to trade their labor for food and shelter. He remembers the draft horses in their leather harnesses and the lean, gaunt men setting out in the predawn hours for a day of work in the fields.

From earliest childhood, Michael has been an integral part of the operations on that farm. Working beside his older brother and his father, he developed a love for the land, a respect for the seasons, and an appreciation for what they have to offer.

Throughout his life, every season has brought its promises and its heartaches. Spring is the time of new life on the farm, of baby chicks and calves and foals, of planting corn and soybeans and hay and oats, and of tiny green sprouts bringing new life to the black soil. Summer is the season of caring for the animals, cultivating and haying, and evenings under the windmill sharing stories. Fall brings the intensity of harvest and moving the cattle in from summer pasture; winter gives the farmer a much needed rest, while the routine of caring for the pasture animals that are now confined is blended with the

planning for a new year.

Michael has seen the dynamics of farm life change drastically as the family survived a tornado that destroyed the farm buildings, a fire that destroyed their home, the Great Depression, and then World War II. He watched as the miracle of electricity came to the barn and to the house, and later as family farms became history while agricultural corporations developed. He had learned how to drive the large draft horses even though he could barely see over the triple box wagon, and years later he watched as the horse era gave way to an explosion of power and the complex machines that replaced hand labor. Through it all, the Cotter family farm has survived.

From Michael's childhood memories to his adult years, his stories give us insight into his concern for people and the environment, the life of the land, and the seasons that determine its care.

In more recent years, Michael has begun to call himself a storyteller. His memories of growing up on that Minnesota farm have given him the opportunity to appear on storytelling festivals, radio, and television throughout the United States. *Growing Up On A Minnesota Farm* is a blending of his stories with photographs and narratives that define rural Southern Minnesota in the mid-20th century.

Working on this manuscript, we found that while Michael's stories defined farm life in the mid-20th century, we also felt that occasionally a more specific description of farm duties or equipment was necessary.

These descriptions of farm life define a part of history that is only in the memories of those who were fortunate enough to have lived through those times. When these people are no longer here, their stories will be lost, unless we are wise enough to listen and to record them. Farming has changed drastically in recent years, and even though there are many who long for the self-sustainable farm and the honest, hardworking families who kept them alive, there is also the realization that this lifestyle is a thing of the past; corporate farming is here to stay.

From the beginning of European settlement in America, the family farm has been the very foundation of our nation. Since that time we have grown from an almost totally agrarian society to one of urban living. Children expect their meals to come prepackaged, precooked, and ready to eat after two minutes in the microwave. For most people milk and carrots and hamburger come from the grocery store, and no more thought is given to it than the cost of the weekly shopping trip.

This memoir takes the reader back to the time when cows were milked morning and night, apples were picked from the tree in the yard, and asparagus grew near the house, a time when farming was more than an occupation. It was family blending with the seasons in a never-ending cycle.

CHAPTER 1

Spring

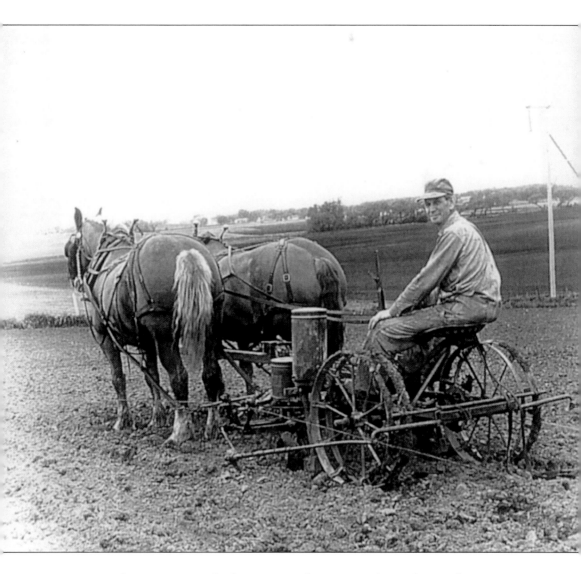

SPRING PLANTING. This man is wire checking corn with a two row, horse-drawn planter. Farmers took great pride in their straight rows lengthwise and crosswise.

My name is Michael Cotter, and I'm a third generation farmer from Austin, Minnesota, where the land is flat and the soil is black; and many of those farms have been in the same families for a hundred years, and ours is one of those farms.

Our environment has changed so much in the 60 years that I have farmed, and it's easy to forget all the birds and animals that were once a part of our lives. So I've written this poem to remember the meadowlark, my childhood messenger of spring, who fell victim to modern agriculture.

On a crisp, clear morning,
When spring seemed far away,
I would hear the shrill, clear whistle,
Of the meadowlark each day.

The whistle spoke of faith and hope,
That winter now had passed.
He announced that spring was on its way,
With no more wintry blasts.

Now spring must find its own path,
Without that cheery call.
The town crier on the fence post,
Is not heard at all.

At first we did not notice,
That he had gone to stay.
Didn't know how much I'd miss him,
Until he went away.

Like the meadowlark that we believed would be there forever, my parents believed that a boy who loved and understood the farm would help it continue on forever.

When I was five, Minnesota farm kids didn't go to kindergarten. Many country schools at that time started them in first grade at five years old, and the young people would go with an older brother or sister to begin their learning process. My mother insisted that we all go to the parochial school in Austin—four snowy, cold miles away— so kindergarten was not a part of my experience.

My training ground was our big barn with all the animals there: cows and horses with their young and occasionally a little pen for a group of pigs that were born out of season. The barn was filled with their various odors as well as those of the fresh mown hay lingering from the previous summer and the sweet-sour smell of the silage in the storage room next to the silo.

Every one of my days was spent there and my most constant companion was Al, one of our hired men, a man with a crippled leg and beautiful white hair. We didn't know much about Al. He had just drifted in one day and stayed for four years. There might have been a marriage in Al's background, and I think maybe a child, but I barely remember his ever speaking of them.

When spring came to that farm and the barn became too warm, the doors were opened and the cattle let out. Baby calves running up and down the alleys would stand at those doors and look out. The melted snow and the running water and the mud was a much bigger world than the one they knew in the confinement of the barn. They would look out and then decide it was just too big, then continue their playing in the alleys. There would come a day when we decided to put them out. The younger and stronger men would throw them out the door—they could handle them by themselves—but Al and I would have to work as a team. I was fast and could run, and Al was strong and slow, and together we pushed those reluctant calves toward that open door. When they couldn't resist anymore, they would give a great leap over the puddle of water they saw and usually land spread-legged in the mud. After a moment of shock they started looking at this big new world. By the time we would come with the second calf, the first one was already running headlong across the yard. It was a lot of work pushing eight or ten calves through that door one at a time, and when the last reluctant calf joined the group that was now running with wild abandon, it was with a deep satisfaction that we stood and watched all these young animals. They would be running in their big new world, spots of mud on their coats from falling, never

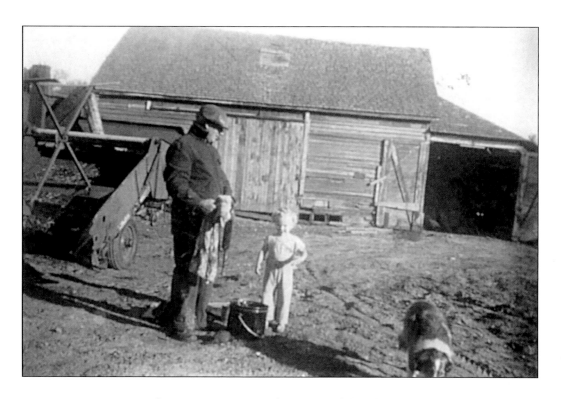

DAILY CHORES. Routine chores are interrupted to remind the child that the spring sun may be warm but the air is still cold. The granary with its leanto provides storage for grain and machines.

remembering to stop in time for a fence.

I have fond memories now of standing in the barn, not yet in school, with Al, an old but gentle man, and laughing with delight as these young calves took on spring.

The coming of spring meant hard work for everyone on the farm. Even the youngest were expected to take on bigger responsibilities with the chores as the men were getting ready for fieldwork.

One of the early sounds of spring was that of the fanning mill cleaning grain. The fanning mill was a machine made of sieves and screens that blew air through the grain as it passed over the screens. This allowed the dirt and chaff to be removed from the grain, and cleaned the seed for the new crop. This was before electricity had come to the farm, and the fanning mill had to be turned by hand to build up air pressure, a very monotonous

job. It took two people to prepare this seed: one to shovel in the grain and bag the seed, and the other to turn the mill. A kid arriving home from a day of sitting in school was the perfect replacement for one of these men.

Pretty soon Dad would be out in the field on his old G John Deere with steel wheels. His 15-foot disc would cut last year's corn stalks and mix them with the soil preparing a seed bed for the grain. This was followed by four horses and a drag, which smoothed the surface of the soil, completing the preparation. The next step was the end gate seeder, sometimes called a shotgun seeder, mounted on the back of a wooden wheeled wagon, and driven by a large sprocket on the wheel. The seeder consisted of a tank holding about three bushels of grain and two fans that turned at high speed. The grain fell on these fans and they scattered it evenly

SPRING MEANS MUD. Mud in the farmyard is an inconvenience, but moisture in the field is vital

for plant life. These horses appear to be waiting for drier weather.

in a 25-foot area. This required two people: one to drive the horses in a straight line and the other to shovel grain from the wagon into the seeder. Like before, this seemed to be another perfect job for a kid coming home from school or maybe even kept home from school to help. The importance of spring planting forced schoolwork to take second place.

There was one more operation with this grain planting project. Dad came with the disc, running lighter now, to throw a little dirt over the newly planted oats. Since this was happening in early to mid-April, it was cold in those flat, wind-swept fields, quite a change from the school day classroom.

Once spring field work started, the weather dictated that every clear day there was much to do. After the oats were planted, preparations started immediately for corn. Corn planting required a more finely made seed bed. Three passes were made over the field to break up the lumps of dirt left from last fall's plowing. First came the disc; a few days later the quack digger rooted out any greenery that was growing; last came the four horses pulling the drag. Now the field was ready for planting. If the planting was interrupted by rain, then the unplanted portion of the field must be dug and dragged a second time so that the sprouting weeds were killed. This gave the new corn an even chance with the new weeds. Corn planting was the most prestigious job on the farm. The best man and the best team of horses were needed.

In my earliest years, seed came from ears of corn carefully selected and shelled by hand during the winter—another good job for kids. By 1940, even my Dad, who was a little old fashioned, switched to hybrid corn and bought the seed in 56-pound bags, which equaled a bushel. Corn planting day was a big day. First the check wire had to be rolled out. This was a smooth wire either 80 or 160-rods long with knobs spaced 40-inches apart. This was the same width as the planter rows. That allowed the hills of corn to be spaced 40-inches apart both directions, making it possible to cultivate in both directions. This was the best form of weed control at that time. It also offered farmers a chance to compare their planting skills with the neighbors' on a Sunday afternoon drive.

In the late 30s we started growing some soybeans. These were planted about an inch apart using 60,000 seeds per acre compared to 18,000 for corn. Early in the fall, the soybean plants were cut and dried, and used as a high protein cattle feed. Farmers were all experimenting with how to plant and use this new crop.

Over the years we planted a variety of crops on our farm and each one brought new challenges.

As long as I can remember, we had a special spring ritual on our farm. It was called "taking the cattle to the north farm." The north farm was about seven miles from the home farm, and where our home farm is flat, the north farm is rolling and wooded with spring-fed streams running through it. The north farm is 100 acres of ideal pastureland with hills and woods for protection from the elements and a permanent natural water supply. I loved that spring trip to the north farm. For one thing, it meant we would no longer have to feed and care for the cattle in the barn. And they wouldn't return home until almost snow time.

There was a lot of excitement on the day of the cattle drive in early May. The route to the north farm was by many small farms and through the town of Oakland, a village of 25 houses. In my early years about 60 cattle were driven to the north farm by a crew of five or six people, usually three men and my brother and I. Everyone was walking except one of my sisters or my dad who followed behind in the car. Good runners were very much in demand as someone always had to be in front of the herd to keep the cattle from running away, and good cooperation was necessary to cover all the driveways we passed and still keep the herd together. It was a time in history when all farms were fenced, so only the driveways and open gates had to be protected. There was a sense of

adventure and excitement for both the cattle and people as we started on that trip.

The gate was open from the muddy farmyard, and that herd of 60 cattle wanted to run when they felt the freedom of the open road. Getting them past the lawn and heading down the road was the hardest part. Some were interested in eating the new lush green grass along the road, and some were interested in running, so it was hard to hold them together. By the third mile the herd had settled down and both the cattle and the drivers were getting tired.

About that time we entered Oakland, a town with two streets, a half dozen businesses, a school, a grain elevator, three churches, twenty-five houses with gardens, and a train that went through every hour. We passed by two beer joints, and the patrons would crowd the doorways enjoying the drama of the cattle drive.

Our trip had to be timed so we missed the trains, and we also wanted school to be in session or on a holiday. When the cattle turned on the road by the school, we were on the last part of the journey. If our timing was wrong, that would be when school was dismissed, and those noisy kids would cause us to lose control of the cattle, and they would begin running through the back yards and gardens. That was when it was important to be a swift runner, and usually we were able to get the cattle under control again and heading down the road. Years later people

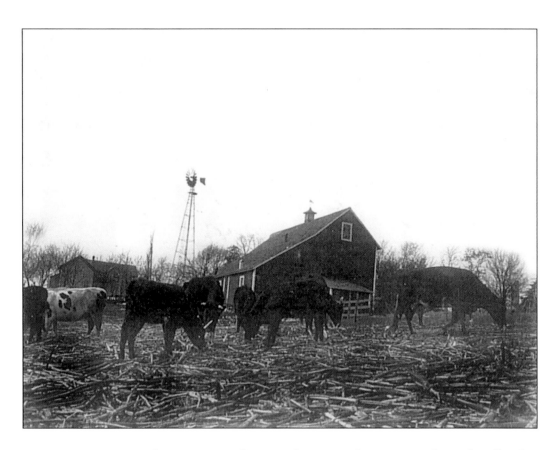

Wintered Over Cattle. These young cattle are picking over the remains of corn bundles that had been thrown on the ground for winter feed.

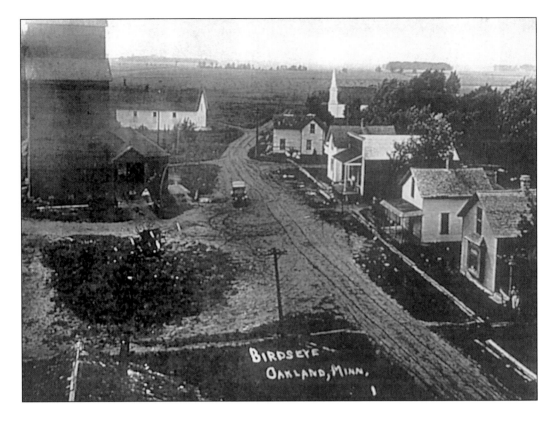

Oakland, Minnesota—1930s. You can imagine the excitement when cattle were driven down this main street in Oakland each spring on their way to summer pasture and again on the return trip in the fall.

told me how they missed the spring and fall ritual of the cattle drives through their town. I was surprised to hear that, because I remember them hollering and running after me with their rakes raised as they tried to protect their gardens.

By the last mile everyone, cattle and people alike, were realizing how tired they were, and when we finally came to the gate of the north farm, it was a welcome sight. In the sheltered areas of the rolling hills the grass was lush and the cattle would stop and start grabbing big mouthfuls of it. Both cattle and people felt a sense of accomplishment, and for just a few moments we stood and watched them enjoying their new home, knowing that in late fall, ahead of the winter storms, both cattle and people would be

anxious about the return trip. For almost six months the cattle were free and we were free of the chores. These trips were one of my fondest memories.

It was an unusually dry spring and the dawn was breaking just when I left the house and started to walk down the gravel road. The long grass of the road ditch was wet with morning dew as I walked through it and crossed a little pasture. I was headed for a tractor out in the field.

As I passed the huge culvert that serves as a cattle crossing under the road and then walked out into the pasture, my mind went back in time to when I was a little boy and that pasture was much bigger, 80 acres or more. All our 20-plus draft horses, and almost 20 cows that we milked each day, had to be

chased through the underpass and into the barnyard about this time every morning.

As I walked towards the tractor parked at one end of the field that was formerly a pasture, I remembered those mornings when I was young, when the horses were not willing to work and would not come in. They would resist, and would not come to the barn.

Some of them would gather on the one little high spot on the otherwise totally flat pasture. This higher mound of soil could not hold all of them, so only the leaders would gather on this knoll like a group of bandits planning their strategy. This was a mound where my older brother said, "Indians are buried."

The horse that was their leader was a sway-backed old mare named May. She had an eternally cranky disposition and her ears hung sideways and did not sit straight up on her head. She had a large lump on her knee—testimony to a bad wire cut when she was young. On the days that the horses under May's leadership decided that they would not be caught and worked, they would stand on that mound and watch us approach, because then all the men and boys on the whole farm had to go after the horses to bring them in.

I can still remember the smell of the prairie grass and the wet dawn as we walked toward that group of horses. Under May's guidance, they would take off in two different directions, splitting us up as a force, and the morning's stillness would be broken by the sound of those galloping horses and the squeaking of their stomachs that often happens when big horses are out for a run. They would circle around behind us and gather once more on that mound. My dad and the hired men and all of us would be sweating, and the men were swearing as we again tried to round up the horses.

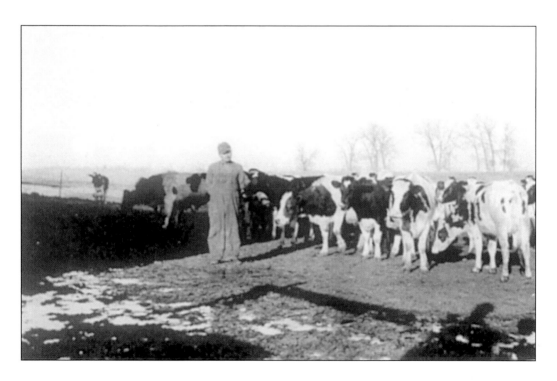

YOUNG HOLSTEIN HEIFERS.. A farmer and his herd of springing heifers (due to calve in early summer) enjoy a spring day in the warm sun.

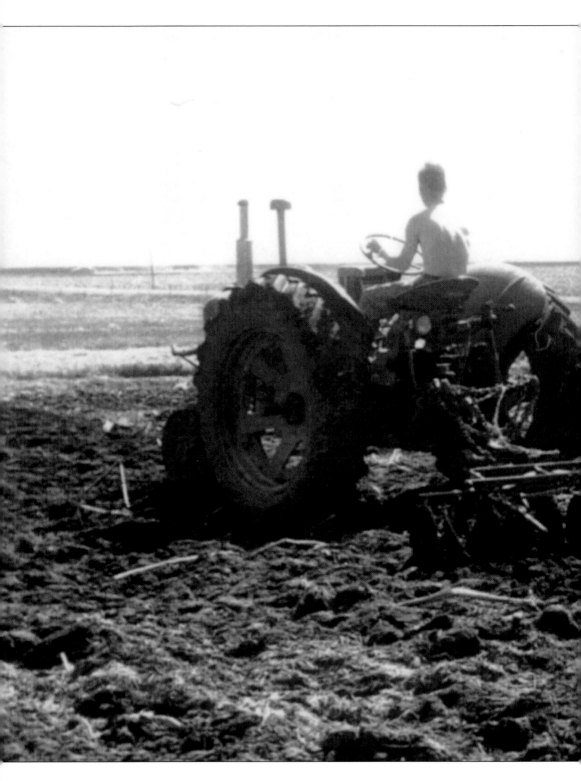

Soaking Up the Sun. This young man, with his 1940s tractor and tandem disc, is working on last

year's corn ground preparing it for planting.

The past memories faded as I thought of the job I had to do. It was with apprehension that I approached the tractor whose cab windows and tires were still wet with the heavy dew, even as the sun rose, promising a very warm day.

Canning peas were now planted in this field where the pasture had once been. Peas are a delicate crop, and they are planted near the surface of the soil, but they must have moisture. The night before as we finished planting, lightening flashed in the west, promising a storm. The big tractor was left hooked to a heavy roller, even though I'd hoped that it would rain and the roller would

not be needed. Its purpose was to seal the dry soil and, by its sheer weight, keep the moisture around the seed. The field must be rolled as quickly as possible, before the day got too hot. I was so wishing I'd done it the night before. The diesel engine roared and the tractor with its cab and big tires rolled across the ground, soon raising a cloud of dust from the dry soil, dust that would stick to the surface of the tractor, leaving a funny design on the wet metal hood.

As the tractor rolled swiftly across the field, my mind again went back to the time when this was a pasture; and I tried to locate that important mound where my brother

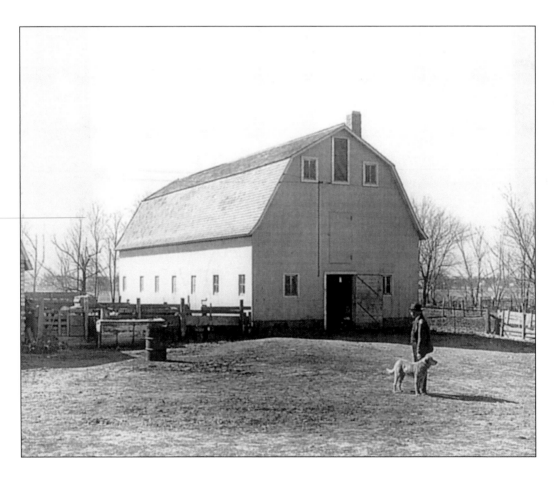

Success. This farmer has everything he needs for a successful operation—a new barn, a good dog, a strong work ethic, and a belief in the future.

said Indians were buried. But so much had changed. The ground had been under the plow for over 30 years now, and the patches of pussy willows and the deep depressions that we used to call buffalo wallows were all worked smooth. I remembered when as little boys, my brother and I would go out among those buffalo wallows after a storm. They'd be filled with water but still have grassy bottoms. We'd take off our clothes and each one would have his own little pool to play in. The only challenge was finding one without thistles. The Indian mound was then located by our north line fence. It would have been easy to find today, except the fence was no longer there.

I could still see my dad's face as he would look at the high fence that separated our farm from the next one. It was an unusual fence with double rows of netting wire 7-feet high and many posts, some of which were anchored in cement. It was a fence meant to last forever. My dad hated it. He'd always say, "That's the bank's land. The bank got all those farms," meaning during the Depression. He would get that look on his face that said, "This should never happen to our land."

The fence is no longer there. Many years later Interstate 90 separated that piece from the rest of the land that belonged to the bank, and it became a part of our farm. I used the farm loader to pull and lift those fence posts with the attached cement bottoms. It was with a strong sense of pride that I tore it

OUT TO PASTURE. After a long winter confined in the barn, these cattle will experience six months of being on the pasture.

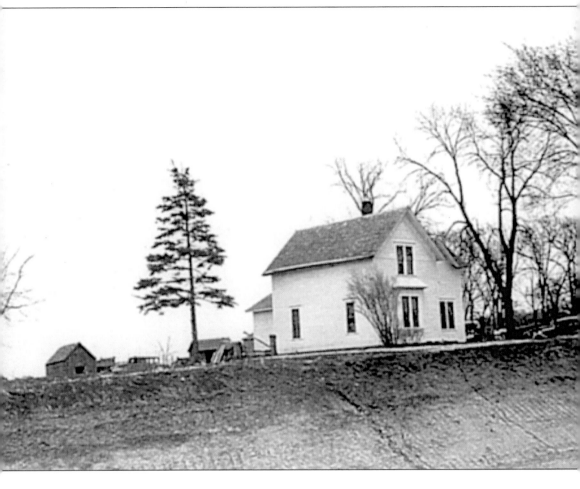

Rural Home. This farmhouse appears to be the only remaining symbol of a once thriving farm. A grove of trees often became the final resting place for old machinery.

down. Now the land was mine. Although, by that time, my dad was long gone, and it was like I was doing his will.

The sun was getting hotter and I had almost half of the field rolled. By now, I knew there would be no rain that day, so the urgency was great. Yet I still kept looking for that mound. My mind again went back in time to the day when my brother and I were young, about 11 and 14 years old. A wild, Hereford bull was kept in that pasture. He was fleet of foot and had a cranky disposition. He was also undaunted by that formidable fence, because on the other side were golden

Guernsey heifers. They belonged to the Streveling golden Guernsey herd owned by the bank. These young heifers were almost of marriageable age, only waiting to be mated with the appropriate golden Guernsey sire.

That day we saw our Hereford bull over with them. He had broken a part of the fence again. The man in charge of that herd, a slight-built man who was the caretaker on that farm, had talked about a lawsuit if our bull continued to get into that pasture. I remember my dad's angry face as he towered over that man. Physical strength was Dad's power, and he did not believe in talk

A CROSSCUT SAW. Women's work was in the home. This young woman is breaking tradition by helping with cutting up a fallen log.

about lawsuits.

To my brother and I, he gave the stern responsibility of seeing that the bull did not get over there again. So that day we were sent out, both pretty afraid, walking across the 80-acre pasture. We jumped over that high fence and walked out into the big pasture owned by the bank where the bull stood ready to challenge us.

His name was Domino, and he weighed about 1,500 pounds. The Hereford bull has a white head that's all curls, and Domino's curls were thick with dirt, because he'd been plowing into pocket gopher mounds

showing these golden Guernsey heifers how terribly masculine he was. For me to really explain this, I need to put it in Catholic terms. In those years, a young Catholic woman of marriageable age who was properly raised spent her free time, while waiting for the appropriate young man to show up, in an organization called the Young Ladies Sodality. These young women did things like serving at church dinners, leading prayers in front of the church during Lent, helping at the Catholic Library, and making long visits to the church to pray.

It was like these golden Guernsey heifers,

in all their innocence, were that Young Ladies Sodality, and here was a sex maniac in their midst with mud hanging from his curls. There was a feeling of sex in the very air itself.

Our protection from that bull was the big fence, but it was a long ways away. My brother had some protection my dad didn't know about. He'd brought his brand-new shotgun. It held three shells. He said that he didn't plan to use it, only if the situation got desperate.

As we approached the herd, Domino with a deep bellow turned to challenge us. In no way did he plan to leave those golden Guernsey heifers. My brother, who was to later become an attorney, told me to go off at a right angle, and if the bull came for me he would use his gun. I somehow let him talk me into that, and as I moved off, the bull came charging toward me.

When I saw him coming, I ran for the fence, the ground flying under my feet. After what seemed like an eternity, I heard the shot echo and the bull roar. The dust rose up from his coat where the pellets hit, and he wheeled around to fight whoever that adversary was. By now Domino had his rear end toward my brother, and he fired again. With the second shot, the bull went into full flight. I can still remember our exuberance, as we were running and screaming at each other.

When my brother stopped and fired his third shot, the bull bellowed again. We were in total control. Domino was fleeing in panic. Sex was the furthest thing from his mind. He didn't bother to find the hole in the fence that he'd come through. He made a brand new one. I can still see that fence's wire netting fly as the bull hit it at full speed. He was racing for the safety of the barn. Home had never seemed so appealing to him, and those young innocent golden Guernseys were no longer a priority. My memory has a clear picture of his broad behind bouncing over that mound where I wondered if Indians were buried.

The field was almost finished and the sun was high in the sky. The tractor was warm and dry, and there was no sign of the streaks of the early morning dew on its metal hood.

I couldn't find any trace of that mound. Thirty years under the plow made too many changes. The landmarks are all gone, and I know that I'll never again find that mound, the mound where I believed, "Indians were buried."

Like the Native American before him, the farmer's love of the land never garnered respect in the urban society.

Consequently, I always wanted to be an expert. Experts have respect because of their ability in a certain field, and they are always able to command good money and much attention.

When I was a little boy, draft horses provided most of the power for farms. People sometimes said that the only thing farmers were experts on were horses' rear ends, which held a grain of truth, since at that time, farmers spent many days following draft horses.

We knew this was not a compliment, and most young people left the farms and found jobs that were more admired. This was most unfortunate because even though the number of draft horses has greatly declined, we seem to have accumulated a great number of horses' rear ends. The unfortunate thing is that all of the experts that understood them from life-long studies are gone. They've been replaced by whiz kids, political analysts, and marriage counselors who are not equal to the job.

Have you ever seen a political race or a marriage breakup that did not involve at least one horse's rear end? It's sad that the real experts are gone when they are so needed and that they were never paid for their knowledge.

I wrote this poem called, "Dragging With Four Horses," as a tribute to those long gone experts.

Life was more simple then.
That's what they always say.
Then the stories always harken back,
To happenings of bygone days.

One job I recall,
From that more simple time,
Was dragging with four horses,

A cowboy sits on top a horse,
At a distant mountain gazes.
The smells of prairie, horse, and leather,
Fill his wind blown days.

The farmer stands on loose black dirt,
And for his eyes to rest,
Are four large horses' rears,
And a long day of test.
Those four must pull together.
Walk in a straight line.
Discipline needs administration,
With a skill sublime.

Slow horses brought to speed,
By throwing lumps of dirt.
The timing all important,
So the driver is not hurt.

Never spook a slow horse,
Fresh off pasture grass.
Nor any other laggard,
Known for having gas.

And holding them in line.

The talent needed for the job,
Wouldn't make your buttons bust—
Needing feet slow to blister,
And being able to breathe dust.

Now these loafers must be punished.
That's a known fact.
Refrain from throwing dirt their way,
Until the wind is at your back.

A toast to bygone heroes,
Of sweat and dust and heat,
Following four large horses,
On calloused, tired feet.
No one gave them loud applause,
Nor presented a gold pin.
Their lot to cope with horses' rears,
Until the crop was in.

At the end of the Second World War, there was a rapid change from horse farming to machine farming. In the 1960s the 100-horsepower tractor was introduced. Prior to this time, the tractors ranged from 20 to 60 horse. The biggest tractor on our farm was a 55-horsepower machine. Then they came with the 100 horse, and where this doesn't sound like a big change,

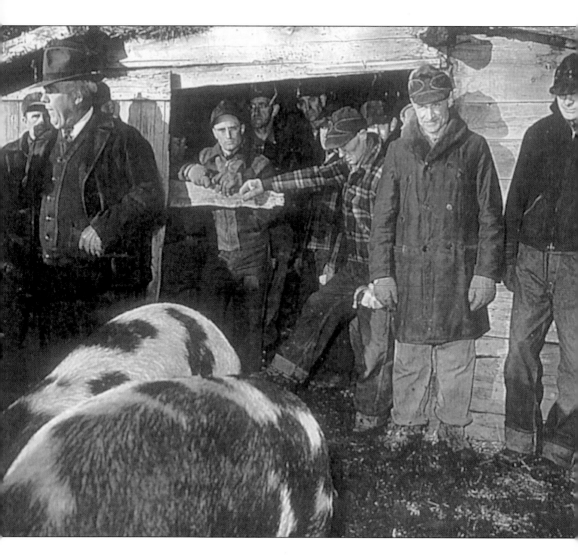

Spring Farm Sale. Early spring sales provided the opportunity for bargain hunting and socializing. A farm sale might indicate retirement, an estate settlement, or financial problems.

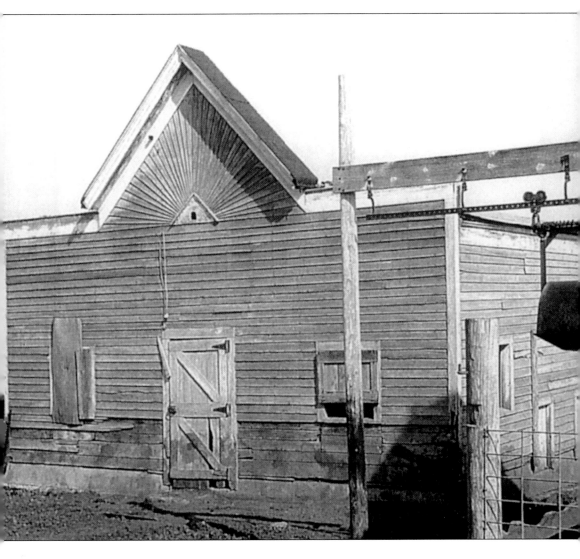

Unusual Hog Building. This creamery, built in 1892, was moved to an Alden-area farm and converted into a hog house.

A SIGN OF CHANGE. The feed company sign on the small granary and the neglected appearance of the barn and silo indicate that this farm has evolved from a dairy operation to a pork producing enterprise.

those wheels had to be doubled to utilize the power. Very shortly we were introduced to the 200 horse, and then the 300 horse, and even the 400. There didn't seem to be any limit to the power, because these were the four-wheel drives. Each tractor had eight large tires standing as tall as a man.

These large machines needed large fields, and so drainage ditches were dug in that flat, black land. A drainage ditch is a canal 10 to 14-feet deep where the water runs only in the bottom 2 or 3 feet in the dry season. Three feet below the ditch bank, tile lines were laid like spider webs that fanned out into the low swamp area, and the fields became large.

Other changes happened at this time. As those fields grew in size, some farms grew, but many others disappeared.

If you were to drive west of Austin on Interstate 90 and look to the south, you'd see a hundred acres of very flat land. That's part of our farm. When I was a little boy, my brother and I would trap muskrats in the winter for spending money. One day I stood on what is now that field trying to count the muskrat houses. There were so many I could not count them.

The story I want to tell you is about one spring day, while operating a four wheel drive tractor, I was pulling a 35-foot-wide disc along the edge of this ditch bank where many little stones had been brought up from deep in that earth. Ahead of my tractor was a bird called the killdeer. These are little, land birds with a small body sitting on top of quite long legs, and when they run they almost look like they are floating on the land.

Killdeer have a couple of special characteristics. First, their cry sounds a lot like their name. But the most noticeable trait is the way they defend their nest, which is just eggs placed among those little rocks. Their eggs match the stones perfectly. The killdeer protects her nest by drama. She acts crippled, and with a wing dragging and looking very helpless, she tries to lead the enemy away from her nest.

This spring morning that bird in front of that big tractor began her familiar drama. First she dragged one wing, fluttering just in front of eight, big, rolling tires, trying to lead the tractor and big disc off to the side and away from her nest. Of course, with these big machines, there is nothing to do but keep going, even knowing that the nest must be near.

Soon she's back again, more crippled than before. Both wings are dragging now, almost tumbling along the ground, barely staying clear of the eight big tires that are steadily rolling. Again I have no choice but to keep going.

The bird comes the third time. This time it's different. Like life itself, the pretending is now over. She's going to take her stand. With a piercing screech that is heard above the sound of the engine, she stands her ground in front of that big rig.

I stopped the tractor and pulled the kill switch. When that big diesel engine stopped its roar, I was shocked at the silence. It became so still. I was able to hear the water running in the drainage ditch. I was even aware of the birds singing along the ditch bank.

I looked down on that killdeer standing tiny in front of the tractor. She was just looking at me. She wasn't as tall as the rubber lugs on those eight, big tires. Because there was no one to make fun of me, or to question "why," I said to that bird, "You have got to show me where it is." That's when the magic happened. It was like she understood. There was just a moment's hesitation, and she moved off the corner of my tractor, spread her wings, and sat down. Defying her instincts, she showed me the nest.

I started that diesel engine, and with the hydraulic lever, brought that disc up on its transport wheels and with almost a foot of clearance, that machine rolled carefully over the top of the bird.

Then returning those sharp, disc blades to the earth by means of the hydraulic, I opened the throttle, and that black, diesel smoke rolled. Soon those wheels were rolling at 6 miles an hour again.

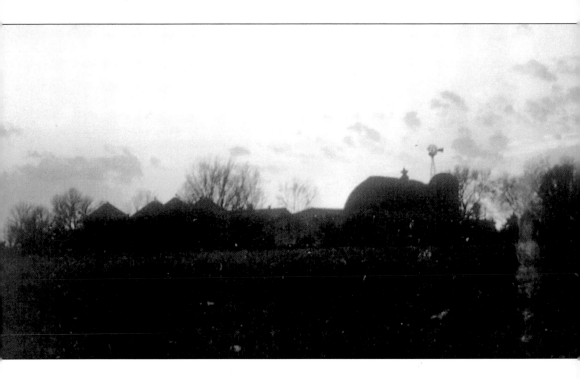

A SPRING EVENING. The evening sun silhouettes the Cotter farm showing several decades of growth and expansion. The windmill and barn remind us of the 1920s and 30s, and the grain bins symbolize the changes in more recent years.

I turned and looked back through the dust, and I could barely see the bird in the distance.

I knew then that our time together was over, and that's my story.

CHAPTER 2

Summer

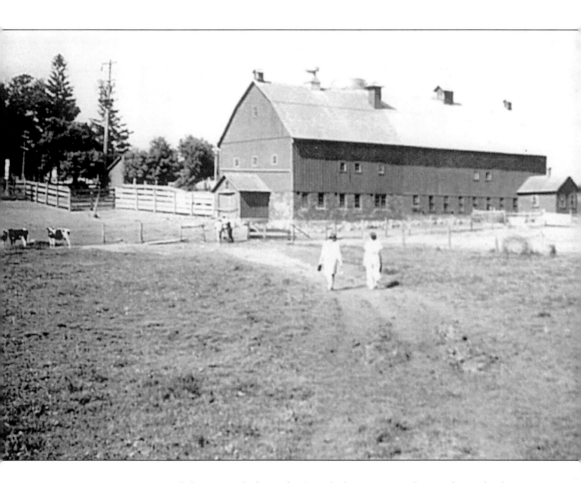

SECURITY FOR THE FARM. A good dog rounded out the family farm team. Skipper brought the cows in for milking morning and night, and he served as the trusted watchdog—the alarm system while his family slept.

I believe our parents teach us many lessons, lessons from what we have observed and maybe have temporarily forgotten. Some of them we learn long after the parents are gone.

My dad was born in 1876. I knew him mostly as an old man. At times I felt cheated that I had not had a young father, but as I enter the second half of my life, I realize he taught me many things. One of the lessons I learned from him was the ability to entertain myself. A good example of this happened on a stormy June night when I was about 13 years old.

At that time we had a dog, Skipper, who was a really bright, ordinary farm dog, kind of smart and kind of helpful, part shepherd, part collie, and part something else. In my younger days he had been my very best friend. Now, being about eight or nine, he was getting old in a dog's life, and he and my dad were beginning to find each other.

With all his qualities, Skipper was most of all a wonderful watchdog. And at night on that farm, he always let you know what was going on. He had about three barks. One was just a little, sharp, pleasant bark telling you that things were okay, and he was out there. The second was a deeper, serious bark saying there was some situation, but that he was going to investigate and for you to stay tuned. The third was a heavy, growling bark that said, "Someone or something is around the farm that should not be here. Get out here immediately."

Skipper, for all his good qualities, had one serious character flaw. He was scared to death of thunderstorms, and when they happened, he wanted desperately to be in the basement by the old coal bin.

Now my dad had lots of good qualities, but he too had a serious character flaw. He never worried about getting people's names right, or animals' names in general. Even though Skipper had been around for nine years, Dad never pronounced his name right. Instead he called him Dog or Zipper.

We had a neighbor named Mr. Cipra. Dad referred to him as Mr. Zipper, sort of like he was happy to have one name do for all.

We also had a neighbor, Mr. Schlichter, who came from Germany. He was quite radical in his speaking and a very old man. Since this was the time of the Second World War, Dad referred to him as Mr. Hitler. Unfortunately, once when Mr. Schlichter came to the door, my dad forgot and called him Mr. Hitler. Mr. Schlichter got mad, and that was the one name that Dad never used again.

Down the road from us, there was a family named Gerlach, a father and mother and seven sons. My dad never got their name right either. He called them Garlic. He had a real simple way of handling it. He called them Old Garlic (Old Garlic was much younger than he was), Young Garlic, and Mrs. Garlic. Young Garlic included all seven sons.

The story I'd like to tell you is an example of the way he knew how to entertain himself. I think he learned it by spending those long winters on the farm in the 1880s and 90s when travel was so difficult.

This story takes place the night of a June storm with lightning and thunder and pouring rain. As usual, the family was gathered in the kitchen for the evening. It was before TV or FM radio, and Dad, who always went to bed early, wanted to hear the news before he retired. With the lightning, the radio was so filled with static that he couldn't hear much of anything. He was quite frustrated, so it was almost with a sense of relief for all of us that Skipper began to bark, signaling there were things that needed attention outside. He went into his most serious bark almost immediately.

Dad went from window to window peering out into that rainstorm, in hopes that the lightning would help him see what the problem was. Unable to see anything except water at the windows, and grumbling loudly so the whole family was aware, he went down the steps from the kitchen to the back entry, which also led to the basement. He turned on the outside light, so he could see who or what was causing the problem. Then he pulled open the door to look out into the storm.

Suddenly there was a tremendous racket, the sound of swearing, and a wet dog racing down the basement steps. We heard words like, "The damn fool almost knocked me down the steps—the damndest dog I ever saw in my life."

Dad came back into the kitchen grumbling about the stupid dog that could have knocked him down the basement steps. He turned the radio on again with all its static. In general he was frustrated 'cause all of us knew that Skipper had won that round. Skipper was now in the far corner of the basement near the coal bin where no one could get him out—the place he wanted most desperately to be when there was a storm.

As my dad sat in the kitchen, unable to hear the news, feeling outwitted by a dog, and in general in a bad temper, there suddenly came a knock at the door. Everyone was startled, and even Skipper barked from the far corner of the basement. I guess he was feeling pretty guilty that he was neglecting his watch dog job. Shortly there was a louder knock, and we realized that my dad was knocking on the kitchen wall near the radio.

This time there came a louder bark from Skipper who was having serious problems with his conscience. My dad, knowing he had everyone's attention now, went to the back door saying in a loud voice, "Who could that be at this time of night?" He pulled opened the door, and again in a loud voice so Skipper could hear, he said, "What are you doing out on a night like this? Come in. Come in."

"Woo, woo, woo, woof, woof," Skipper barked, as he came flying up the stairs. He was desperate now to resume his guard duties. He raced out the door and into the storm, anxious to encounter the people who had come to that farm. My dad, in a now cheery voice, hollered, "Good night, Zipper," and then he slammed the door.

I was looking out the window and in a lightning flash, I saw this dog in a classic pose—three feet on the ground and a front paw lifted, looking back, like he was frozen by the lightning, just realizing that it had all been a trick. Skipper had his pride. He

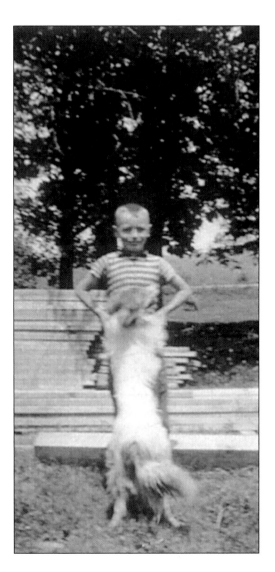

Skipper and Michael. In 1941 life was good for a Minnesota farm kid—a summer day, his best friend, and the knowledge that he is an important part of the team that makes the farm run smoothly.

didn't come back and whine and scratch at the door. He just went on out to some shed where he would burrow under something, and trembling, wait for the storm to end.

My dad didn't need any more excitement. He was on his way to bed, chuckling as he went, every so often repeating the phrase,

"Good night, Zipper," and laughing again. I remember hearing the bed springs up above the kitchen where his room was. As the springs creaked, I heard him chuckle once more when he thought of what a good trick he had pulled on his old friend, Zipper.

When I remember that time, after all these years, I think about the ability he had to entertain himself and to make his own life kind of fun. In a time when we seem to depend on others so much to entertain us, I am grateful for what he taught me.

I also learned that, in all of our lifetimes, much energy is spent in matching and mating—always looking for that perfect other. Whether it is a pair of shoes or matching furniture, we are always looking for that perfect mate.

When I was a young boy, the idea of finding that perfect match meant just one thing—to match up a perfect team of horses. Much energy and planning went into deciding what two horses would work well and look well together, because teams of horses at that time, first of all were very important, and secondly they would be matched up pretty

A Storm Building. Skipper was the perfect watchdog, but his fear of storms was a weakness that he never overcame. Michael's dad believed that fear never replaced duty.

much for life. They matured together, sorta like a couple, and they complimented each other in their working and pulling. They depended on each other so much, because they were a team.

About this time in history my father was approaching old age, and agriculture was on the threshold of revolution from the draft horse to the modern, powered machinery. Because of my father's age, he was unaware that this big change was coming, and he was still living very much in the past when draft horses were the only horsepower of agriculture. On our farm we had 20 big draft horses. They ranged from half grown colts to old, work worn horses whose days were numbered. In the crop of young colts that were coming up were these two full brothers with identical white blazes on their faces—a beautiful chestnut and a bay. They were only a year apart in age, and except for the variation of the color, they were almost identical. This was going to be that perfect team that my father had always dreamed of.

As these two young horses matured, they seemed to fulfill his fondest dream. They

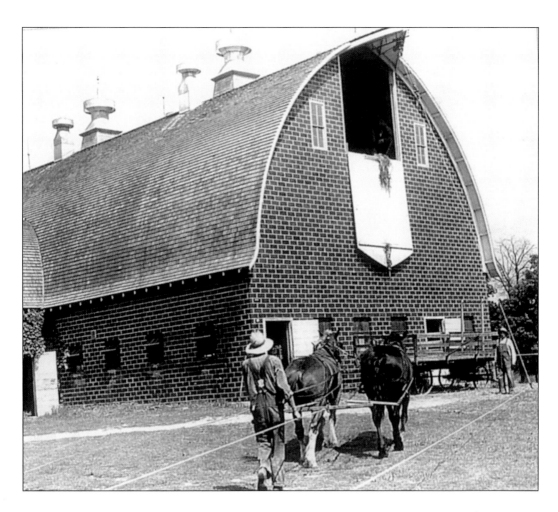

HAYING SEASON. Haying is a time of much confusion and extra work, racing against the weather. A small kid often got a bigger job than usual and his dog was his sidekick.

35

stood majestically and their stride and size and shape, everything about them, was similar. Sometimes on Sunday morning we would be coming home from church, and all of those horses would be grazing in the pasture beside the road. If those two young colts happened to be standing together, he would stop the car and look at them. We would all have to watch as he said, "Look at that team. They are the perfect team. They will be the best team of horses we've ever had on this farm." Then he would point out the way the wind blew their thick manes, the way they stood shoulder to shoulder, that identical white blaze on each of their faces, and how they walked and stood and did everything that a perfect team should do.

When the time came for that team to be broken, the man who was to do the job was named Mike Volmer. Mike was a very quiet man with a severe drinking problem, but his love of horses was unsurpassed. In fact, that seemed to be really the only love in his life. Most of the time he hardly said a word, though he always remembered to thank my mother at the end of each meal. But on the weekends, when he sometimes got drunk, he talked incessantly. Most of his conversations were about the horses he had trained, and how he could talk to them, and how they understood him.

One of those weekends, he had gone into our darkened barn where the large draft horses stood. He had called them by name and then slapped on the rump a flighty sorrel named Bob. It seemed he needed to prove to himself that this horse knew his voice so well that he would stand. This time it didn't work. Mike was found, with a huge gash in his head, lying behind the horse. He'd narrowly missed death, because that hoof had struck him only a glancing blow.

Mike Volmer was a respected horse trainer so he was the only person on our farm that drove this young team, and he named them Captain and Dan. They looked every bit of my dad's dream. They were a perfect pair. When Mike would drive them he would be so proud, because they walked with heads held high and eyes that were wild. It was like the dream of perfection engulfed them. They held a common destiny.

One day Mike was raking hay with this perfect team. He was using a side delivery rake which rolled the swath of hay into a windrow. The distinguishing characteristic of a machine like this is the guiding pole, the tongue. It goes between the two horses and is held up to their collars by a neck yoke, and on the other end of the pole, between the wheels of the side delivery rake, is the seat where the driver sits. The job was going well because the horses moved fast. It was a windy day and there seemed to be excitement in the air.

As he was raking near the road, an old, white furniture truck came down the road behind them. Because of the wind blowing and the blinders on the bridles, the horses did not see the truck until it passed. It had a broken end gate flopping and making a banging sound. This spirited young team jumped sideways, like on a given signal, and the pole on which the seat was anchored snapped and drove itself into the sod. The rake went into the air and over the top of Mike Volmer, and he was thrown to the ground.

Then that beautiful team ran away. They tore through several fences, and the side delivery rake eventually pulled free from them, but not until it was just a twisted mass of metal. When the horses were finally captured, they were bleeding from hundreds of wire cuts, and just trembling, frightened animals. We knew that beautiful team was ruined.

Mike Volmer was never able to finish telling that story. The runaway story was retold whenever he was drunk, which was more often now. He would go back again and tell how there was nothing he could do when the horses jumped and snapped the pole, and he flew, "ass over appetite and the rake ran over me and I was lucky I wasn't killed," was the way he put it.

Even though the story was told and retold, he never seemed to be able to heal the memory. Mike left our farm. It was as if he could never stand the pain of what happened

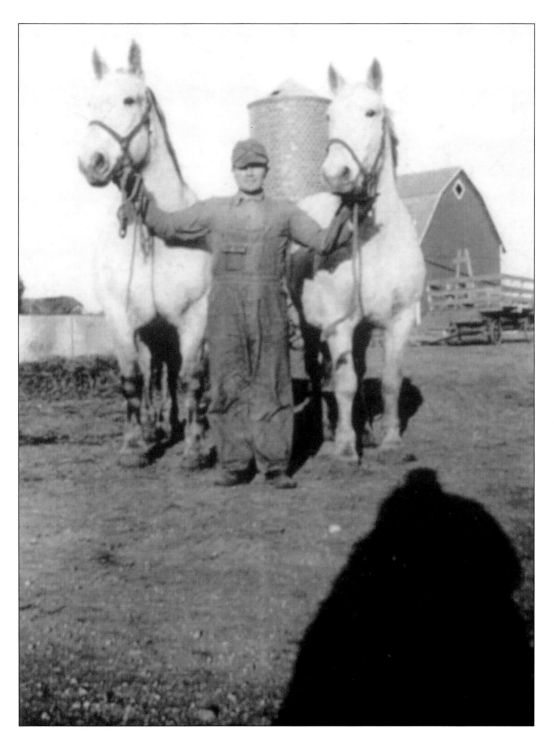

THE PERFECT TEAM. *Farmers dreamed of owning a well-matched team. This team worked well together, they were paced evenly, and they were sized well. A farmer was proud to have a team that was "up on the bit."*

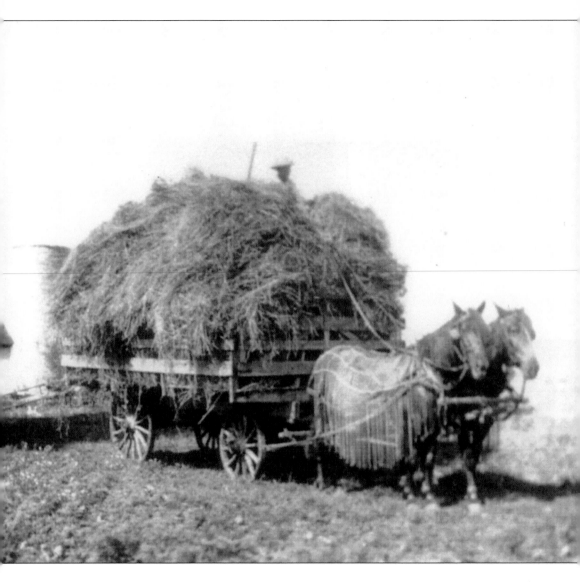

A JOB WELL DONE. A skilled farmer built this balanced load of loose hay. A caring farmer protected his horses from the flies with boughten fly nets. This combination of values guaranteed success.

to those horses.

In spite of this, my dad was not ready to give up the dream. He was determined this team that he had waited so long for would continue on together. So we had to develop a ritual on our farm. Each morning, just as the sun was coming up, there would be this great excitement in our farmyard, as these two wild horses were brought out of the barn and hitched to the old steel-wheeled John Deere tractor of Dad's. It took about two or three men to handle this job—one of them holding each of the horses and another driving them. Then at a signal, the horses were told to "go."

I can still see it in my mind as those two horses lunged into the harnesses, and the tugs creaked, and the metal hames groaned with all the power put into them, as those harnesses were stretched to the very limits. That old heavy tractor began to roll ahead and those three year old, two thousand pound horses lunged faster and faster trying to run away with this load. Then my dad would holler "Whoa" and set the brakes on the tractor. Those horses, who could no longer move it, would just stand there jumping up and down, and there was lots of excitement around them. After about a half hour or so of this, Cap and Dan, wringing wet with sweat, would be hitched to an implement and headed to a field for the day. They were treated differently than any of the other horses, they didn't come home at noon to eat and rest like the others. They were only given a drink of water, and then they continued to work until the end of the day. Only certain people could drive them, because they were very hard to handle, and they were known as runaways.

One spring Saturday my older brother Dick was going to plant soybeans with this team. We went through that early morning ritual, and then the horses were driven a half mile across the field to where the planter had been left from the previous day's planting. Cap and Dan were hitched on to it, and they planted beans all day long.

Toward evening, my dad and I walked out to the field where Dick was planting. We were to help him hitch this team onto the old wagon that held the soybean seed to bring it home. I still remember those horses striding across that field, with their huge powerful bodies and their big hoofs, still carrying their heads high after that long day. Their thick coats were caked with the dried sweat that told the hours they had toiled, but in their movement it seemed like they were still as fresh as in the morning, even though my brother and that team had planted many acres that day.

Together we moved Cap and Dan from the planter to the wagon, and my brother and my dad got into the iron-wheeled wagon along with all the buckets they had for planting. They started that half-mile drive home. The trip was along a lane that was separated from the newly planted field by a barbed wire fence. The sun was setting on that fresh planted earth, and it was a peaceful scene. But not for long. The horses had been accustomed to the quietness of the planter, and as soon as the wagon rumbled, they were spooked by the strange sound, and they bolted.

The scene was utter chaos as they raced along the fence, the buckets flying out of the wagon, and both my dad and my brother falling down in the wagon on those beans that were like standing on roller skates. My dad was yelling at the top of his lungs to "pull on the lines and stop those damn horses."

The barn was looming closer, and those horses were in full flight when my brother was finally able to brace himself against the front of the wagon and pull on those reins with all of his might. At that moment, one of the reins broke turning the horses right into the fence. They tore through that fence and out into a big cornfield. As they crossed the fence line, the wagon wheel bounced over a rock, sending my dad up into the air and out on the ground like a cork popping out of a bottle.

My brother was left without his instructor. But with the one rein he was able to keep those horses running in a huge circle—the soybeans and buckets scattering all the way.

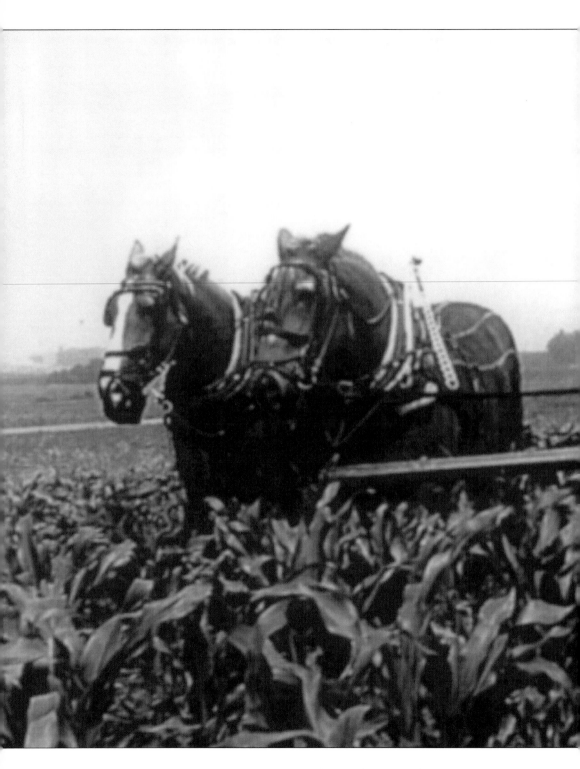

Working Together. It takes a good operator to handle four horses and a two-row cultivator in tall corn. The nose baskets, usually used for protection from flies, were probably used here to

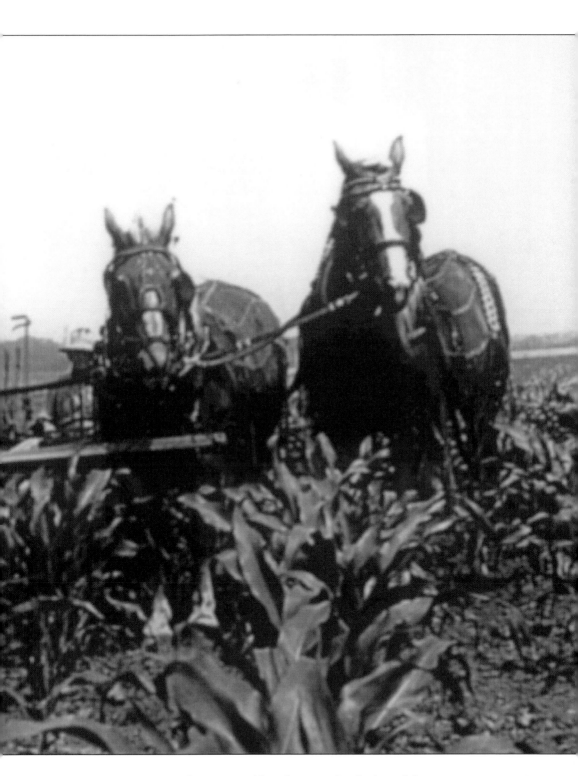

keep the horses from eating the corn and breaking up the rhythm of the team.

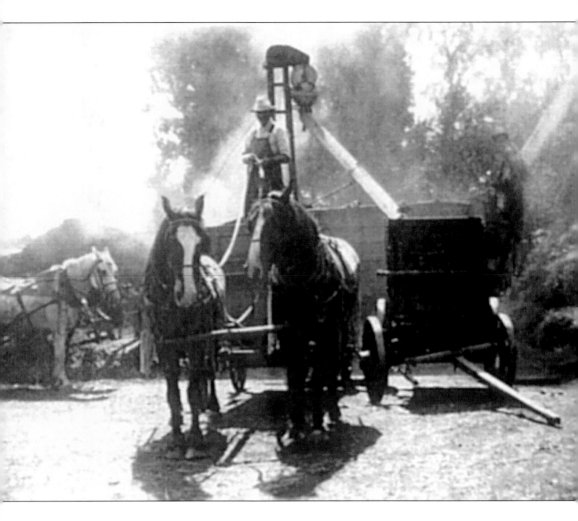

A Job for Dependable Horses. The team that hauled grain from the threshing machine could not be spooky. They had to be able to stand, unwatched, for a period of time amid noise, dust, and confusion. This was no job for colts.

Eventually, after what seemed like a long time, those horses could run no further, and they stood trembling with sweat and foam running down their legs in streams. My father had picked himself up by the fence, and without coming over to the horses, he walked for home with a slow, stiff pace. It was the first time in my life that I saw him as an old man. And I realized his dream of a perfect team had died.

My brother and I led that exhausted team of horses home. They were to be split up, never again to be together as a team.

Now there was a theory at that time, among people who drove horses, that you should take a team that had just run away and put new harnesses on them, and while they are still exhausted hitch them to that same wagon. Then in a soft field, with a whip, force them to run again and whip them till they can no longer move. The theory was that the team, with their spirit broken, would never run away again. That theory was not tested here.

Cap and Dan were split up, and each one was put with an older horse. They didn't look good at all, but that was the way they spent their days.

Sometimes on Sunday when we would be coming home from church, and the horses were in the pasture, Captain and Dan would be standing together. My dad would stop the car and comment how beautiful they looked with the wind blowing their thick manes, and with their powerful bodies that looked totally matched, and with the identical white blazes. And he would say, "Don't they look perfect together."

In telling the story of growing up on a Minnesota farm, where high value was placed on a matched team of horses, I am proud that I never saw a horse whipped 'till his spirit was broken.

Horses played such an important roll that they needed to be nurtured and trained just like children.

In early summer, cultivating and haying came close together creating an urgency in our lives. The first cultivation is the most important one for any crop. On our farm cultivating was done either with single row cultivators which required two horses or two row cultivators which required four horses. I was anxious to be old enough to start cultivating, because that meant you were an important part of the farm. One of the things about growing up on the farm, was once you mastered a new job it was very difficult to get out of it. Cultivating with horses required you have a couple of wrenches to set your cultivator, some hard wood pegs that were like safety pins when the cultivator blade hit a rock and snapped back. Rather than breaking the blade the peg would break. You also needed good legs, because the steering was controlled by foot pedals. A half-a-mile row was a long distance when you were riding the iron seat of a cultivator in the hot sun. Fields were usually cultivated three to four times a season.

A well disciplined team of horses was needed for haying.

Probably the most romantic sound in my young life was the sound of that old horse drawn hay mower in the distance. On a late June morning with the wind blowing the prairie hay, the smell of the new mown hay and the ca-chinka-chinka-chinka of the hay mower pulled by two big draft horses made it seem like the whole world was at peace.

I remember lying in the standing hay to watch those black and white bobolinks as they chirped and chattered to each other. They would each sit on a single stem of hay swaying back and forth in that June breeze. This was old-fashioned times, so I used old-fashioned language to describe it as I told my mother that "these birds seemed so happy and gay." Now of course we know better. We would use a more proper term, like they were non-depressed.

When my brother inherited the job of mowing hay, he soon convinced me that this was a job that I would like, because I liked those big horses. He even agreed to teach me how to run the mower. He went on to become an attorney.

Mowing hay turned out to be the most

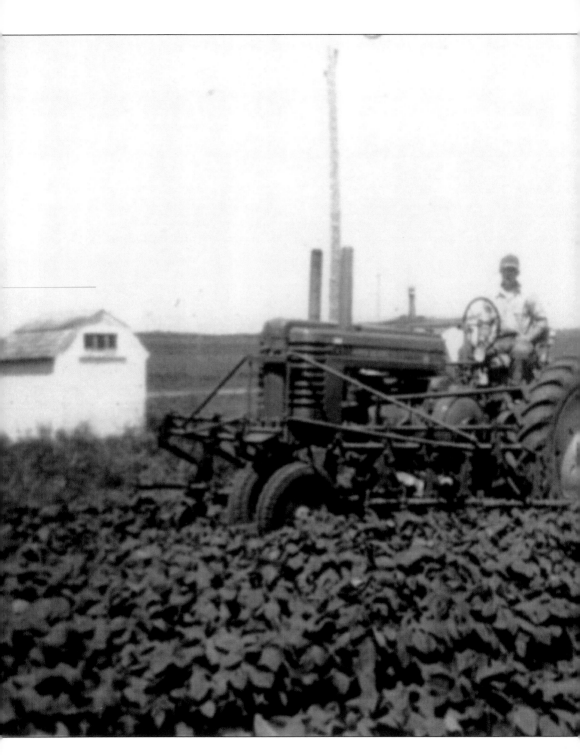

ANOTHER TEAM. These two tractors could do the work of 20 horses and provided horsepower that never needed rest. Lights on the tractor enabled the farmer to work far into the night. This

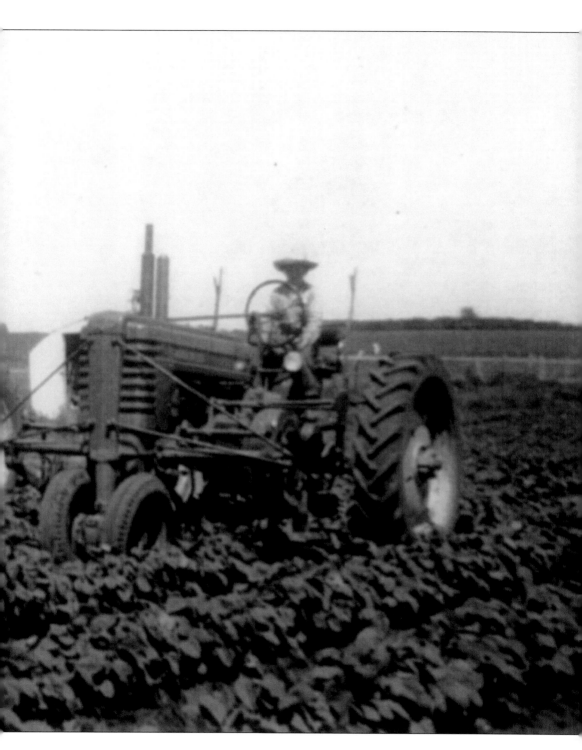

changed the culture of agriculture.

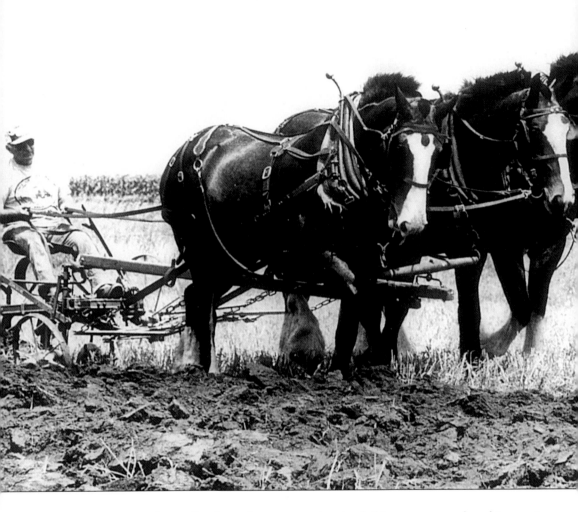

PLOWING WITH HORSES. Long after farms became mechanized, this man remembers his growing up years and the joy of plowing with good horses.

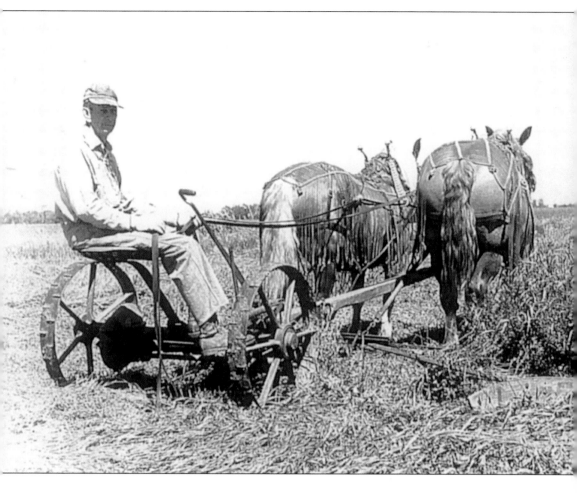

Horse-Drawn Hay Mower. A day spent mowing hay was a day of contrasts: fresh air laden with the smell of new mown hay, the reality of a hot, vibrating iron seat, sweating horses, and the desire for a shade tree and rest.

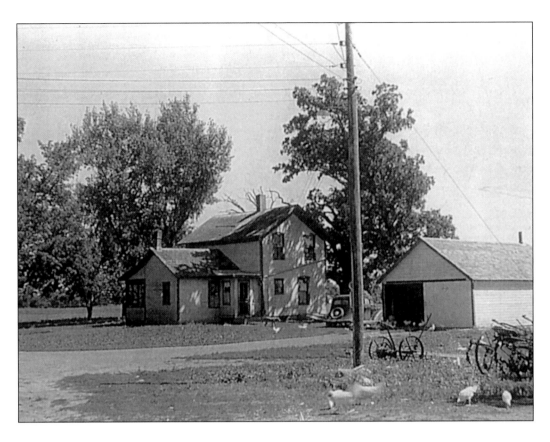

SUNDAY, A DAY OF REST. Sunday was a welcome respite from fieldwork. The horse drawn hay mowers and cultivators were parked, the horses stayed in pasture, the people went to church, and only the chickens maintained their daily ritual.

hateful job I ever had. The hay mower in the distance sounded like music, but operating it was dreary. Because the mower was driven by its big wheels, it pulled very hard. The horses became hot and sweaty and developed sores on their shoulders under those big collars. That prairie hay cut tough and the mower would plug often. The big horse flies came out of that standing hay and bit those horses, causing them to stand and kick which caused the mower to plug again and again. While I was unplugging the mower sickle, the horses would kick again and the sharp sickle would move beneath my fingers. Then the horses would kick over their tugs. These were the thick leather straps from the harness to the mower. While unhooking the straps in order

to get the horse back into position, I would get swatted by that heavy tail that stings your face and cuts your eyes. It was a hateful job.

So it was a wonderful time when the tractor powered hay mower came to our farm. With the power coming from the tractor instead of the wheels, the mower moved swiftly. Also we had started growing alfalfa hay which was viney and more tangled than the prairie hay.

When I would sit on that tractor on a June morning it would seem like I was flying across the field. There were no more bugs or horse flies bothering me. There was the smell of the new mown hay, though I was not able to hear the birds over the sound of the tractor.

But like most jobs it had some faults. Because we moved so swiftly, and because

the alfalfa hay was so tangled, pheasants didn't have time to fly before the mower hit them. One of the duties that went with the hay mowing job was stopping and going back and looking at those mangled pheasants, large and small, and "putting them out of their misery," as the description went. I always remember the looks we exchanged before the pheasant was killed, like everybody knew what was going to happen.

One day I hit a pheasant nest, but I had a little luck. The mower killed the hen, but her eggs were barely touched. So I gathered up all those warm pheasant eggs, putting them in my hat. I put it in the toolbox of the old B John Deere, where the fan blew the heat from the radiator across them, and at noon I brought the tractor and the eggs home.

At that time in history, our farm like others had some of everything on it, including chickens. My mother was from the city and spent a lot of her time proving that she was a real good farm wife. One of her ways of proving that was by keeping chickens. I realize now she hated chickens. My dad also hated chickens. Chickens on our farm were for punishment, and they looked it. They laid eggs everywhere but in the chicken house, and they ran their own breeding program. My mother secretly bought eggs as long as I can remember.

There was a cute little young hen that wanted to sit on some eggs at that time, so I put the pheasant eggs under her, and she

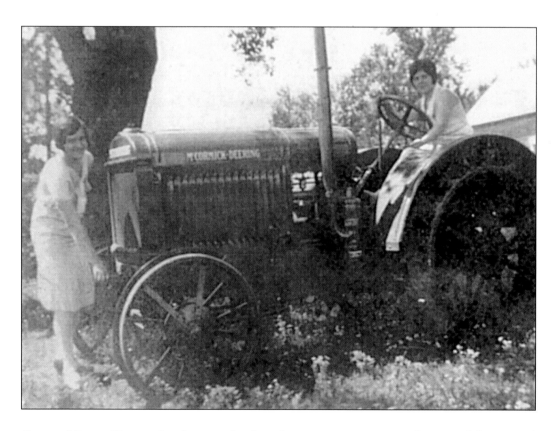

Sunday, A Day of Visiting. Sunday was the day when town cousins came for a good dinner and conversation with the family. These young girls are enjoying having their picture taken by the old tractor and the shade tree.

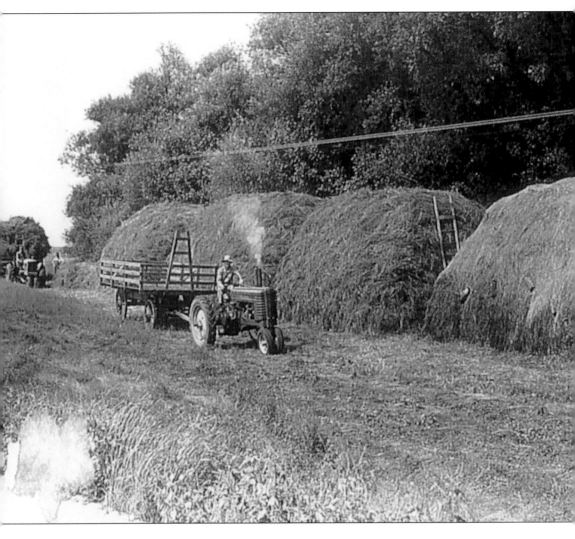

A TIME OF TRANSITION. At the end of World War II, rural America was ready for change. While the haying process still stayed the same, tractors now replaced horses.

eventually hatched them.

About this same time, we had gotten our first power lawn mower. It consisted of an old reel type push mower with a motor on top. We had one area of the yard that was mowed very tight, but beyond the fence the lawn ended, and it became wild with brush and weeds. It was there that the chicken house and some of the outbuildings sat, with a couple of weeping willows forming the boundary.

In the early morning just as the sun rose, it was almost worth getting up to see those mother hens coming out from under the weeping willows, where they'd been nesting with their baby chicks, those little yellow fluff balls. With the sun rising, they would start marching across that mowed lawn where each stem of grass had a drop of dew sitting right on top. Any mother or teacher would be proud, as these mother hens seemed to be vying with each other over who was the

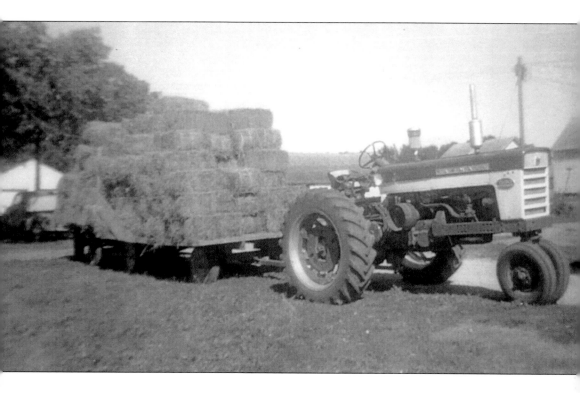

BALERS REPLACE HAY LOADERS—1950s. This tractor is pulling two wagonloads each containing sixty bales weighing 60 to 70 pounds apiece. Manpower was still needed to stack the bales on the wagon and in the loft.

best parent.

There was perfect discipline as they each marched with their little group. Occasionally one of these mother hens would call her chicks together when she noticed some lesson they needed to learn. She would stir something with her feet as she pointed out a couple of things for their information. These little baby chicks would stand in a circle listening intently and being perfect students. When the lesson was completed, they would again spread out on that lawn looking for bugs and pebbles and all the things necessary for chicks to grow into adults. There was perfect discipline. There was no sassing or going off by themselves. It was student and teacher in perfect harmony.

Now the hen with the baby pheasants wanted to get out there and show off her flock on those early mornings, but none of the rules in her book seemed to work. She would coax and plead with her baby pheasant chicks trying to get them out of the weeds and onto that lawn. It seemed that just as she got them out on the lawn so she could hob-nob with those other mothers, a door would slam or someone would yell, and "zip" they would all disappear back into the weeds again. There was nothing for her to do but run after them, calling and cackling, trying to round up those babies over which she seemed to have no control. She soon lost her well-groomed appearance, and stress started taking its toll. Most of the time she was by herself, and I often would notice weeds dragging from her tail feathers.

When my mother would see a young woman in our community that was showing signs of stress like this hen, she would say in a hushed tone, meaning we should never

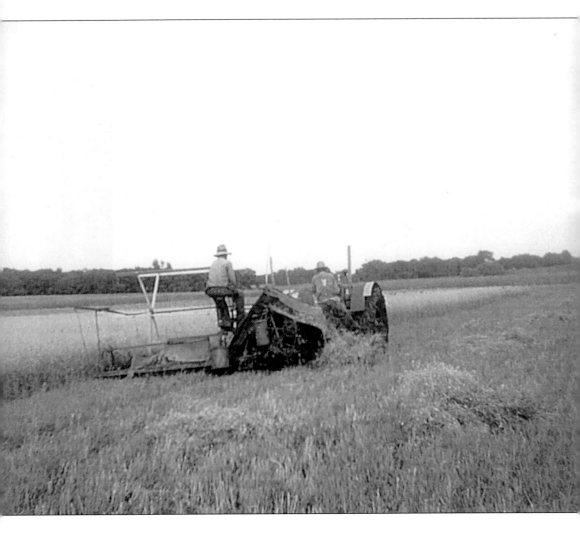

CUTTING GRAIN WITH A BINDER. *This grain binder was built to be pulled by horses, meaning it was ground driven, powered by a bull wheel. It cut standing grain, bundled it, and grouped the bundles for shocking. Because this hot July job was so hard on the horses, by the 1930s farmers were starting to replace them with tractors.*

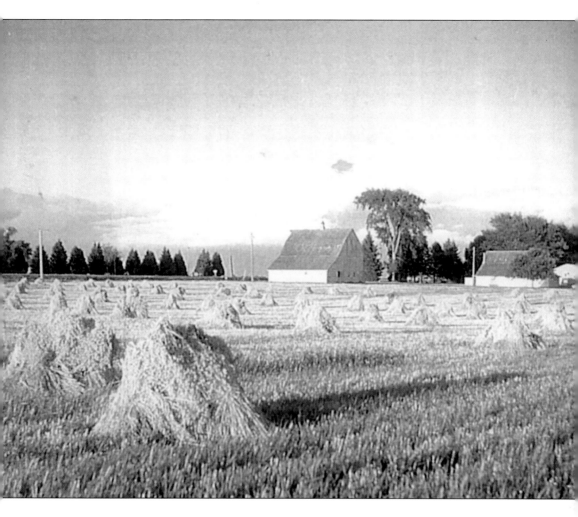

BUILDING TO WITHSTAND THE WEATHER. There were two popular types of shocks. The six-bundle long shock pictured was fast drying but less durable. The eight-bundle round shock was more solid, and some people added a ninth bundle as a cap for rain proofing.

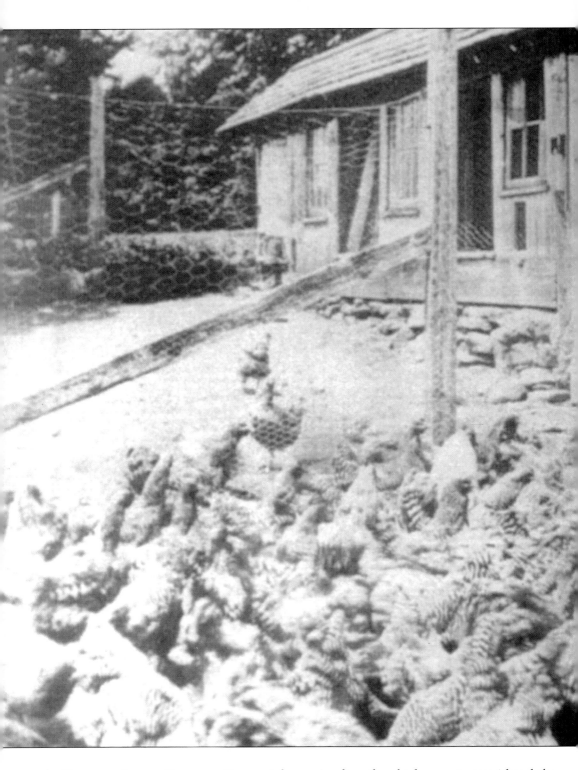

AN ORGANIZED CHICKEN OPERATION. On most farms, tending the chickens was considered the woman's job. She took care of feeding them, and gathering and washing the eggs, and then

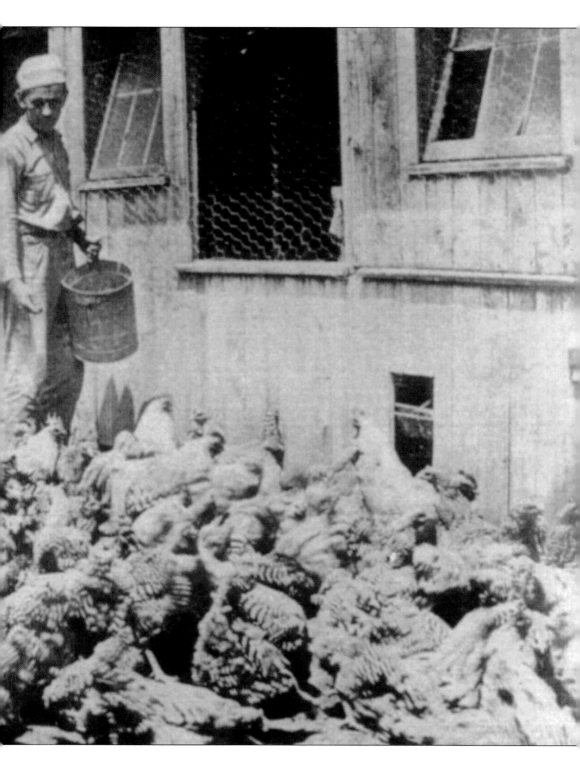

she was in charge of how the egg money was spent.

INCREASED HORSEPOWER. By the late 1950s, farmers wanted more power. This young couple was proud of their six-cylinder tractor, the hydraulic controlled plow, and wheel weights for extra traction. The gravity flow gas barrel provided a ready supply of fuel.

repeat her observation, "You know, she could be a fallen-away Catholic."

Now, of course, it would be handled entirely differently. This stressed young hen would probably join a support group, a group of mothers that were having similar problems. They would have discussions in their meetings, learning how they could cope with their situations. She might have become an officer of the club, or might even be in charge of the newsletter. But this was old fashioned times, so she just got looking more and more stressed.

The pheasants began flying, and this did not help her lot. I didn't see her much now. She stayed by herself, but when I would see her, I noticed her tail feathers bent up, dirty and scraggly, and she was looking more weird, in no way matching that petite little hen that I'd put the eggs under.

One day late in the summer, I came around the corner of our barn and met this hen with her now quite large pheasants. All those pheasants took off, up-up-up over the top of that barn. Our barn is 45-feet high. It was then I understood that hen's tail feathers. She sat way back, bending all her tail feathers up in the dirt as she tried to watch which direction those pheasants were flying. After the pheasants disappeared over the top of the barn, that little hen took off running. I noticed how she ran different than any other chicken I'd ever seen. She was running toward the corn field where the pheasants had gone, a place no chicken ever went.

I never saw this hen nor the pheasants again. I think she decided that parenting was not for her.

As I thought about this story, I realized that I had brought two powerful instincts together

56

that didn't match. This hen had become unlike any other hen that I'd ever seen, and I'm sure the pheasants were different than any other pheasants. They had spent most of their summer trying to work out their relationship.

Farming at that time seemed to be a combination of relationships, and the threshing ritual was another example.

Threshing was probably the most important season of the year in my young life. The whole neighborhood was involved in a threshing ring. There were other rituals like silo filling that also involved the neighbors working together, but that did not compare with the threshing ritual either in length or in drama.

I think what made threshing so memorable was all of the preparation. It started when the old grain binder was pulled out of the shed. This was followed by endless days of cutting grain, always in the hot sun. The person running the binder, usually one of the men, would have to drop the grain bundles in groups of fours or threes or sometimes twos and in straight rows so the men shocking would not have to carry them so far. Shocking was one of the really hard jobs on the farm. The grain bundles were not heavy, but they had to be stood up in really sturdy shocks where they could stand and dry and wait for the thresher. It used to be said that a real good man could keep up with a binder all day shocking. The shocks usually sat in the field two to three weeks and were threshed according to your rotation in the threshing group.

When people got together to plan the threshing run, they had to calculate how early their oats would be ready and how long it would take. And that worked quite well unless the weather turned very rainy. Then people became very anxious about getting their crop threshed. So it was with both relief and excitement when the threshing machine came down the road. The machine was preceded by horses and wagons pulling into our farm yard and going out into the grain field. Even though there was generally no more than ten farms on our threshing run, I remember hearing at one time there were thirty men involved. That was held up as an almost all time high number.

It seemed to be the number that my mother harkened back to in her worst fears of feeding the threshing crew, when she saw great mounds of food disappear off of the table with each setting. My mother was never comfortable unless there was at least four or five women to help, and she made sure that my six older sisters all had a chance to be part of the preparing and serving. They made two sit down meals and a morning and afternoon lunch brought to the threshing machine, so the men could pick up a sandwich and coffee and peach on their way back to the field.

There was a job for everyone in that threshing ritual, even a young boy. The first job was to bring water to the men. Everyone was always hot and thirsty and water was in demand. It was quite a learning experience for a little boy or girl handing that dipper up to a man standing on a wagon. Some men seemed to want to visit with a child. For some it was just the curt acceptance of the water and then they were on their way. Some men with a thumb and a forefinger removed a large wad of tobacco from their mouths before they drank the water. Others didn't bother to do that even though it was obvious there was some in their mouth. We even got to judge a person's upbringing by the way he accepted the water.

The next job for a young boy was tending the grain wagon. There were two grain wagons parked beside the threshing machine and a swinging auger dumped the grain in half bushel amounts in the center of the wagon. The machine weighed the grain in those half bushel dumps and counted every second one on a tally, so at the end of the day or the end of the field, everyone could see what the yield was for that crop.

In our threshing crew, John Rolston was the man who hauled the grain. We all knew Johnny, as we called him, a large jovial bachelor man, who lived with his sister and was always considered very nice to children.

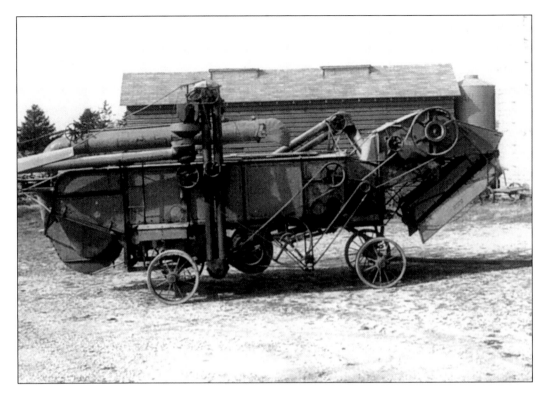

READY FOR THE NEIGHBORHOOD THRESHING RING. Usually one farmer in a neighborhood owned a threshing machine, and after a meeting of eight to ten farmers to set up the schedule, the threshing was done on a rotation basis.

Nice meant he would take the time to set them on the wagon load of grain, then they would ride with him to the granary to unload it, and then he would take the time to set them off again and have them stand at a safe distance while he would unload it.

As a young boy I thought tending the grain wagon meant watching it and not letting it overflow, and I thought it was a very boring job. It seemed like nothing was happening there, yet if you left the wagon for a few minutes and played or visited with another young person, it overflowed. It seemed like everyone knew you had failed in your job.

I tried taking on more responsibility with that job and once I switched John's horses from one wagon to another. They were a very docile team and easy to handle. Now John always unhooked the horses and hooked the

tugs up in the harnesses and acted like he was putting the horses away. I thought he spent too much time switching them, so when I made the switch, I did it the way we did on our farm, letting the tugs drag on the ground and moving quickly to the other wagon. Even though I did the job quickly, he came racing back and in a non-jovial voice, told me not to do that again. I was really hurt, thinking I was helping him. Later I realized that we had many horses and many harnesses and John had only two well worn harnesses, and if one of the horses stepped on a tug it might break it. I was happy when I graduated from the grain wagon.

The next step in training a young boy was tending the blower. It was a job I liked. The blower was a long pipe on one end of the threshing machine that directed the straw

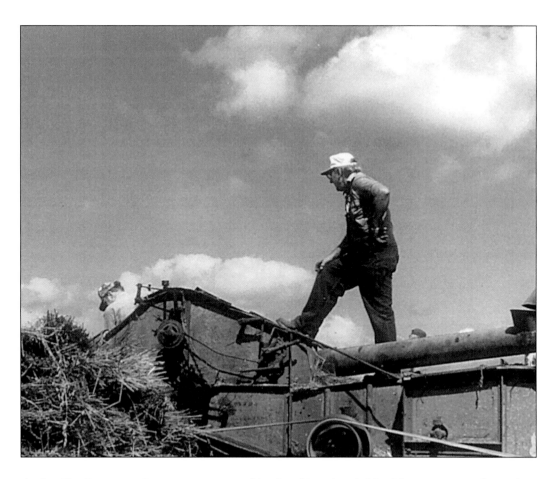

An Old Man Remembers. In a re-enactment of the threshing ritual, this older man remembers when he was young and his strength and endurance made him a vital part of the operation.

upon the straw pile. It had many cranks and pulleys so it could twist and turn. There were a lot of things to move on it. It was said that a good blower tender could build a straw pile by himself without anyone being on it shaping the pile. I'd never seen such a blower operator, and my dad always wanted one man and sometimes two on the straw pile. Our straw piles were meant to last into the following summer and had to be built to shed rain water.

As a blower operator you were instructed to work in harmony with the man on the straw stack, because he probably had the worst job on the threshing crew. Sometimes the man on the straw pile was one of the men

that worked for us, someone who had been mean to me or maybe played tricks on me. So one time I decided to straighten him out and maybe to show off to a friend, I pretended I couldn't understand his signals and turned the blower on him instead. He was blinded by the chaff that enveloped him and waved frantically for me to move it. I pretended I was confused by his signals. Later I had almost forgotten about that moment of getting even with him, when suddenly he appeared at the threshing machine, pulled me down from the machine and stuffed my bib overalls completely full of straw.

Every young man knew that eventually he must take on the job of hauling in the

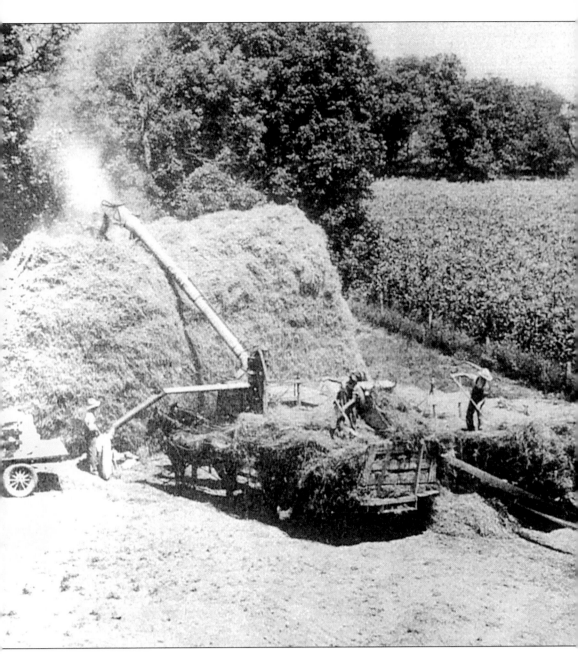

A COOPERATIVE EFFORT. Threshing required the hard work of many men. The least desirable job was building the straw pile, but it required skill because the pile was built to shed water, thus protecting the bedding supply for the winter.

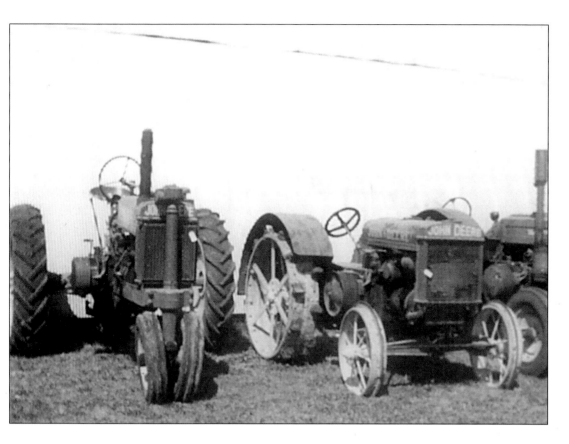

A TRACTOR COLLECTION. The 1929 D John Deere in the center of this picture was one of the early tractors used to power the threshing machine, replacing the steam engine. Now it is a part of an antique tractor collection.

bundles. If he was able to hold his place in the line up, in the work, and in the heat and the sweat, then no one would deny that he was now a man. My older brother had taken his place among the men at the age of 15, and it was a very hard struggle for him. I sometimes had to bring him a lunch in the field where he was working if that farm was unable to feed him enough. By the time he was sixteen the neighbors asked for him when they called for help because they knew he was a good worker. So he had made that transition into manhood.

My chance came when I was 13. Even though I was small for my age, there were not enough men around. Most of them were at war. We had to send two bundle wagons

for the threshing crew and we had no one to run one of them. Mother was fearful of Dad, now in his late sixties, being pushed by younger men. She was afraid that he might over-do and have something happen to him. So in the early morning of a hot July day, with my horses harnessed and fed and hitched to the wagon, I started down the road to the neighbors to join the men on the threshing run. I was excited. I pulled into the field and began loading my wagon, calling to my horses who walked beside a row of shocks to go ahead and stop where they should. In my new role as a man, I was building my first load of grain bundles. The other early arrivers were calling to each other and to me, saying things like, "We have a new man this

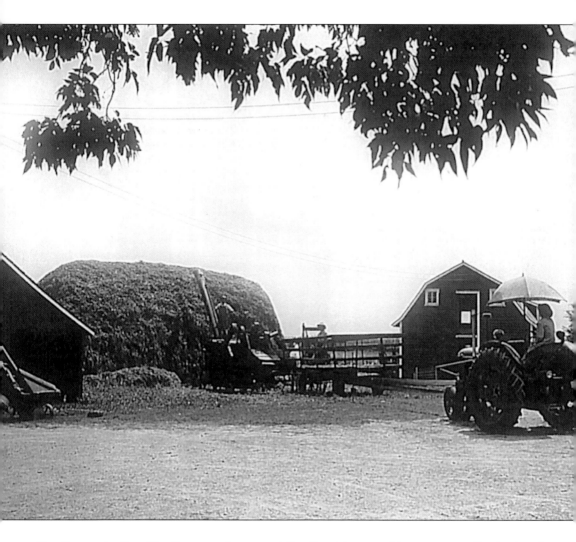

THE END OF AN ERA. The farmer who owned the threshing machine was usually the last in the neighborhood to switch to a combine. This scene, with a more modern tractor and a woman sitting under the umbrella symbolizes the change from a neighborhood ritual to a family affair.

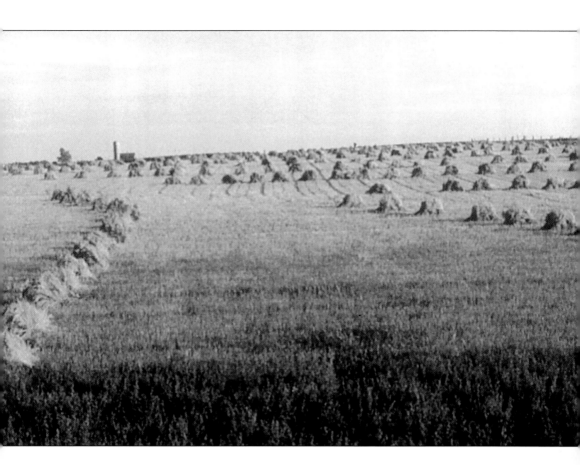

Artistic Composition. The number of grain shocks in this field signify a good yield, and the neatness and order of the field reflect the hard work and the pride of the owner. Shocking was a test of a man's endurance.

morning. I wonder how he will be?" I was very proud and excited as I started the long day. Later I pulled my first load up beside the threshing machine that was just getting started for the day. We had to pull our horses beside the machine in a certain way, always remembering to turn them away from the machine. We had all heard of horses who had had their tails pulled off in the belts of various machines.

Pitching into a threshing machine took a rhythm and a steadiness. The bundles had to fall one right behind the other with the grain heads facing the machine so the threshing could be done evenly. It took a while to get used to the rhythm and to get over my nervousness. Because there was another man on the other side pitching in to the feeder, we both had to keep a steady rhythm. When the man on the other side was finished or arriving late, the other bundle pitcher was expected to maintain that rhythm on both sides of the feeder.

As the morning wore on, my excitement was replaced by fatigue. Sweat was pouring down my face and arms, and because we were short handed there were many times when there was no one on the other side and a double rhythm had to be maintained. As it neared noon, I realized there was no way I would make it through the afternoon. I knew that I could work until noon and then I would talk to my brother and see what I should do.

Noon was a wonderful time with the comraderie of hungry men looking forward to rest and a wonderful meal, the smell of pies cooling in the windows, and towels hanging in the willow tree near the wash basins. I was looking forward to being waited on by the pretty young neighbor girl who was my age but went to a different school.

When noon finally came, a man came up to me and said that my dad had sent him to take my place and I was to go home. Taking my place meant that he would also eat in my place. This was wartime. It was not a time of hurt feelings or disappointments, and the ritual of manhood would have to be put off a year for me. But I will never forget my thirteenth summer when it felt like I was carrying the honor of our farm on my shoulders.

CHAPTER 3

Fall

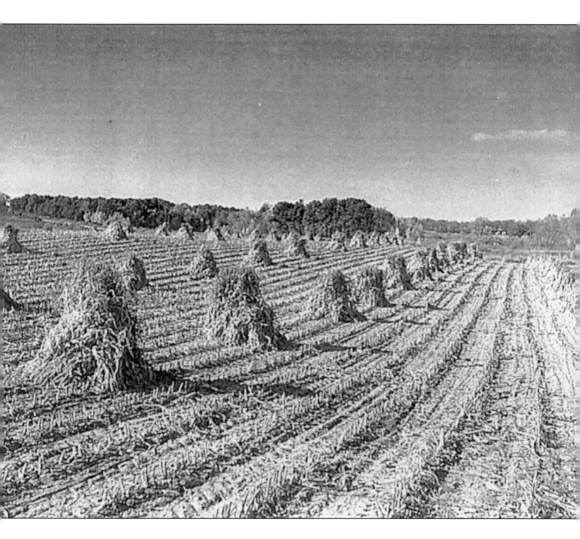

CORN SHOCKS DRYING IN THE SUN. Each shock in this peaceful autumn scene contains up to twenty corn bundles each weighing 30 to 40 pounds and standing more than 6-feet tall.

One late August Sunday morning, I was awakened by a disturbing sound. The sun was just coming over the horizon and the trees and the buildings to the east of the house were sending long shadows across the wet grass of our lawn. The sound that awakened me was that of blackbirds. They were gathered in groups on that lawn making the sound that blackbirds do when they begin their flocking process.

My reaction to that early morning scene was the same as it had been my entire life. "It can't be this late. It's still summer. Why are they flocking?"

That feeling went back to when I was a little boy, and the blackbirds were telling me that summer was ending and school would be starting. The summer had seemed so short and soon I would be putting those summer bare feet into new tight shoes and going back to a school that smelled of fresh varnish, old books, and library paste. All the summer outdoor farm activities would be replaced by confined indoor learning rituals.

In town school, no one cared that even though I was only 10 years old, I had driven horses on a cultivator and worked right alongside grown men. The nuns were more interested in how many library books had been read and if your coloring was improved from last year. Much classroom time was spent having kids tell of the trips they had taken to other states and other cities, and the nuns encouraged them to relate what they had learned and what souvenirs they had brought back. I felt awkward in this setting. I had not taken any trips. Few if any library books had been read. I had done no summer

Sawing Wood—A Dangerous Job. When wood was the prime source of heat in the home, a large wood pile was a source of pride. Fall days were spent sawing logs into stove length pieces that would later be split with an ax.

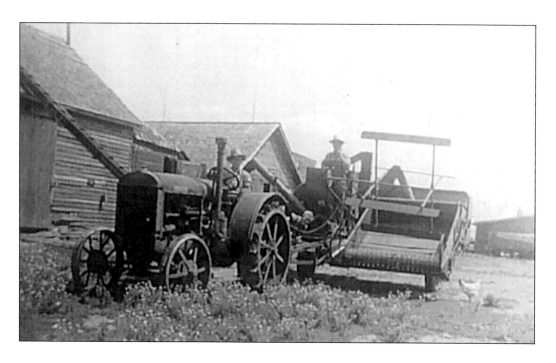

Nineteen-Thirties Tractor With All Steel Wheels and One of the First Grain Combines. Very few farmers believed that these machines could replace the community threshing ritual.

coloring. I had nothing to offer.

It didn't seem proper to tell them that I had taken a team of horses and a wagon, and with only Skipper my dog, I had traveled the seven miles to the north farm pasture and driven that team through two awkward, heavy barbed-wire gates into the stand of trees where our winter supply of oak wood was piled.

No one wanted to hear that as I was driving across that rough pasture on the way to the wood lot, the cattle ran past the horses. They became frightened and tried to run away. I was somehow able to hold them as they were galloping wildly and the wagon was bouncing in the air, and I was able to get them under control before they went down the steep hill and into the wood lot. When I finally pulled the wagon by the wood pile to begin loading, I tied the horses to the tree. I noticed my hands were shaking so I could hardly tie the ropes.

Later when I became thirsty and went looking for water, I followed a little swift running stream back to the place where it made twists and turns. I was looking for the spring that fed it. Finally I saw that fresh water bubbling up from the earth next to a mossy bog. I was able to drink that water deeply because I'd been taught that spring water was very special. I went back to the wagon and finished loading the wood. With the team now quieter, they pulled that loaded wagon those 7 miles back home. It had taken all day. That night I told about the runaway and finding the spring. My mother acted worried and my dad said I'd done a good job. I was very tired but proud.

That first day of school, no one was interested in what I'd learned from that trip.

All of those memories and feelings were brought back by the sound of those blackbirds.

As a young boy on that Minnesota farm, one of the jobs I liked best was hauling a load of grain to the elevator to be ground into feed. It was a Saturday job and lasted almost half a day.

The day started when I got two horses out of the barn, hitched them to a wagon loaded up with oats, jumped up on top of the load, called to those horses, and started out on the four mile journey to the Oakland Elevator. It was a good day when the hired men had the horses already harnessed and standing there, cleaned and fed, waiting to be hitched on to the wagon. Other times the horses needed to be harnessed and gotten ready. Even though they were not our biggest horses, they were still tall, weighing about 1,500 pounds each. This required me to stand on a bucket to reach up over their backs with the heavy leather harnesses. When I stood on a tall tin bucket, my head was even with the top of their backs, so it would be quite a struggle. Farm kids were expected to know how to do this, even though they looked too small to do the job.

The horses that I remember best were Nellie and Beauty. Nellie was a very pretty chestnut-colored horse, and Beauty was a sort of swayback and dumpy acting bay. I always thought their names were backwards, 'cause Nellie was petite and graceful when she walked, and Beauty plodded. But, they were matched in size and weight, and they worked well together. Beauty was a good puller, but she did not step up stylishly like Nellie. With the help of a willow switch, I could still make them look like a classy team.

Nellie was a special horse and was always

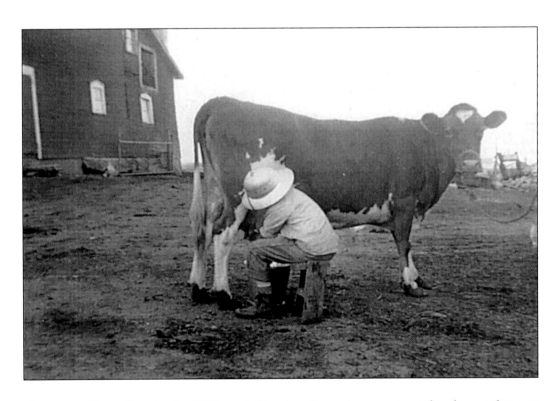

Milking the House Cow. In the 1950s and 60s when farms became specialized, most farmers discontinued milking. Often a family kept one cow for their personal use and she became a pet.

The Farmall 7-Foot Mower

One man with a Farmall equipped with the power mower will cut 20 to 25 acres a day.

Nineteen-Thirties Farmall Tractor and Power Mower. This mower, powered by the tractor, replaced the horse-drawn mower and shortened the time needed for the job.

considered a heroine on our farm. My dad described her as tough. He used to say, "I don't know how a horse that eats so little can be so tough." My early memories of her were when she had sleeping sickness. A heavy cloud hung over our farm as we watched a colt and three of our big horses die. There was a sense of doom about our future. I still remember Nellie standing in her stall, too sick to move, but refusing to lie down. We knew once a horse lay down with sleeping sickness, it would never get up again. So there stood Nellie, a beautiful young mare, swaying back and forth but refusing to go down. She somehow survived that fatal disease, and forever after was considered a heroine. The many colts she had were always highly valued.

On Saturday mornings, I would jump up on that load of oats, with a willow switch that I'd cut for a whip, I'd call to those horses, and we'd soon be trotting down the west road to Oakland.

The Saturday that I want to tell you about, the morning air was fresh and crisp after a heavy rain the night before. The horses were

lively, and the iron wagon wheels rang out on the stones of the gravel road. My dog, Skipper, bounded ahead like a scout. Skipper was kind of a collie, and kind of a shepherd, very small for both because of an early injury. He was wiry and speedy and bright. He could do anything a dog needed to do. He was my best friend.

The best part of the morning was, that even though I was maybe ten or eleven years old, I was doing an important job. I was doing man's work.

We went west on the gravel road, and after about a half mile, we were on a dirt road as we moved into Freeborn County. This consisted of a wagon trail with the grass growing in the center. Even though this road had two little ditches, one on each side, it was not considered a significant road, and most of the year it was not traveled at all. At the very end of the road was a school house, District #6. This one-room, white-washed school house had two smaller buildings out in back. They were outhouses. You knew which was which, because the girl's had a special little barricade for additional privacy.

FALL PLOWING. Before hydraulic power and conservation tillage, a good farmer plowed his land in the fall to assure a good seed bed in the spring.

SHOCKING CORN. Corn shocks, left in the field to dry, were brought in by bobsled for the winter feed.

FILLING SILO. In the 1940s silo filling still required neighbors working together. The green corn bundles were hauled in from the field, chopped, and then blown into the silo where the fermenting process preserved the corn for the winter feed.

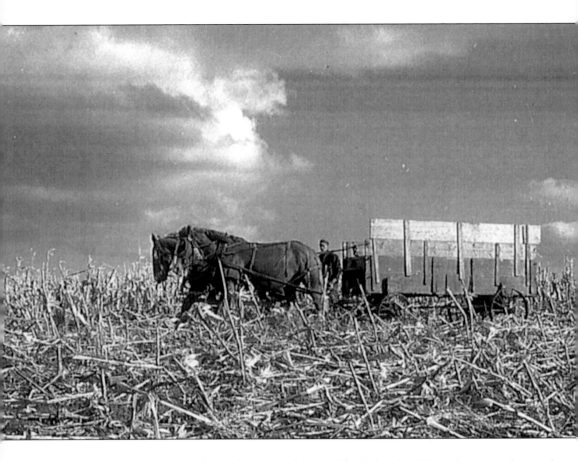

HUSKING CORN BY HAND. A few claimed to pick a hundred bushel a day. This job required a good man, a good team of horses, a high bang board, good standing corn, and working from dark to dark. This ritual ended by 1950.

As we turned north on the gravel road by the school, I wanted my horses to trot and act frisky, because we would soon be passing the Guy farm. This farm was one of the largest in our community and it had many horses. They also had four sons, one of whom was my age. I think they were our chief competition in the neighborhood. They originated from Presbyterian Northern Ireland, and of course, my family came from Catholic Southern Ireland. It seemed natural to me that here my team should look its best, and with a little help from my willow switch, my two horses looked lively and spirited as we passed that farm.

I went north till I came to Highway 16. My

dad referred to that as the state road. The horses' hooves echoed on the cement, and the big wheels of the wagon rang out as we crossed that highway and proceeded north toward Oakland. At this point, Skipper would usually give one huge leap and land up on the load right beside me. Along this road he liked to ride with me, because there were several dogs in the area. At one time he had been attacked by two neighboring dogs, both much bigger than him. One dragged him one way, and one dragged him the other. I had to jump down with my willow stick and hit those dogs, screaming at them until they released Skipper. We were both scared. After that day, he always rode with me during that

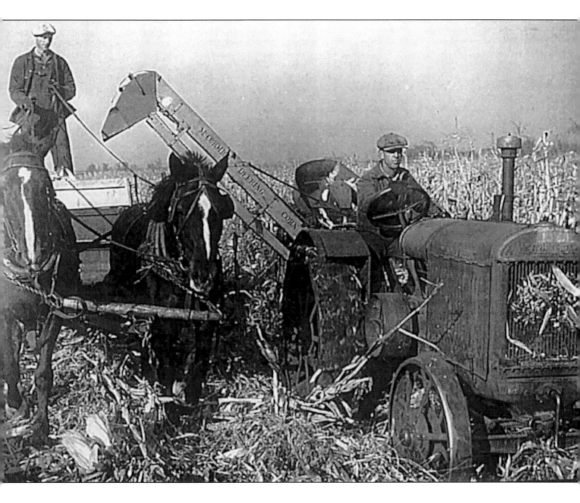

An Early Mechanical Corn Picker. This equipment picked the ear corn and elevated it into the wagon. This operation required a team of horses willing to work beside the noise of the picker and tractor. The corn stalks sucked against the radiator were not a problem on a cold day.

part of the journey. But he didn't just sit, he stood and leaned forward like he was out in front riding shotgun. In the distance we could see the tall box-like elevator, with its roof line standing higher than the steeples of the two churches in town.

As we turned into Oakland and went by the houses, sometimes large, smiling women would wave at me from their back doors. As we passed the taverns, the patrons would be looking out the windows. It seems as though everyone enjoyed watching a young boy and his dog doing man's work.

When we came to the elevator, and the horses started pulling that wagon up the sharp grade, they leaned forward and their hooves dug into the approach. Their harnesses tightened and slid back as their muscles knotted. As they stepped on to the level elevator scale, the load rode easier. When their hooves hit the hollow sounding wood floor and it echoed from the scale, they began to dance and prance nervously. There were always men in the doorway of the grain elevator, watching to see if this young boy could control those horses. Skipper and I

knew we had a big responsibility.

I unhitched the horses from the wagon. It was lifted high into the air by the elevator dump, and the grain was emptied into the pit. Then Nellie and Beauty were hitched back on to the wagon, and we slowly descended the steep grade down from the elevator. As we went down that grade, the wagon pushed the horses, and now they had to hold back to keep it from forcing them to run. Then I had to back the wagon under the grinding machine which was right near the railroad track. The horses would be turning this way and that as we maneuvered the wagon into position. This was all being done under the very watchful eyes of the men who worked at the elevator, and of the town loafers who exchanged the news of the little community

FARMERS COMPARING CORN VARIETIES. Many varieties of corn are planted in a neighborhood. Yield and quality comparisons are an important part of the harvest ritual.

A Bumper Harvest of Corn—1946. Ear corn was fed through the hand cranked corn sheller to provide feed for chickens and pigs.

from chairs in the elevator office.

The grinding was handled by the people at the elevator, so Skipper and I could go over to Hellie's Tavern and spend a nickel. As we walked into the saloon on those hot mornings, the patrons would look up from their beer or their dice game. The men at that time, and it was all men at that time, often seemed to have bleary eyes, or teeth missing, or warts on their faces. Sometimes one of them would get up from his chair and come over to get a closer look at me. He would ask, "Who's boy are you?" for they all wanted to know the patrons that were in there that day. If he would stand too close, Skipper would step forward between us and let him know that we were a team. We were there together.

On this particular Saturday, the bartender came over by the ice cream containers as I began my shopping. He said he had something new. It was called a poosh-up.

It was a cardboard cylinder with ice cream on a stick, and it was the first time that he'd ever had them. Because of the excitement of the new poosh-up, I bought one and then I bought a Hershey candy bar for Skipper. I overspent my allowance, and I felt guilty almost immediately.

With the sound of the train whistle in the distance, my problem had to be set aside. The train would be going right past the shed where Nellie and Beauty were standing, and they were afraid of trains. Skipper and I ran back to the horses, and I stood in front of them to hold their bits and to reassure them as the train drew near. "Wooo-wooo-wooo" went the whistle of the old steam engine. Nellie and Beauty shuffled their hooves back and forth, and their eyes were big and frightened behind the blinders on their bridle. I held tightly to their bridle bits as the train, with one loud and long "wooooo," rumbled past. The buildings shook. After the

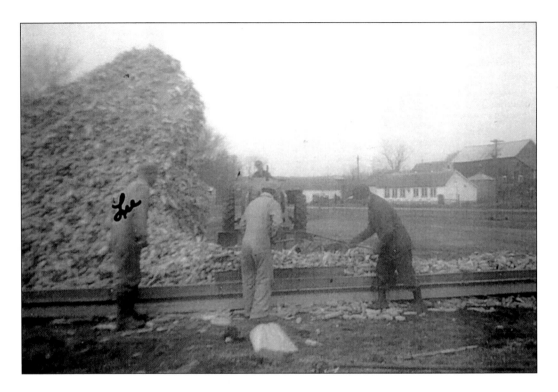

LATE FALL CORN SHELLING. By the mid 1950s, the hard work of shelling corn was eased by the use of a hydraulic tractor loader and a modern conveyor called a corn drag.

train passed, the crisis was over, and all we could hear was the sound of the grinder at the elevator. Calmness returned.

When the feed was finally loaded, we started home. I stood ankle deep in the ground feed. Skipper made a marvelous leap that carried him up beside me and we headed out of town. Again there were people in doorways, smiling and waving, like they were bidding me a safe journey—a young boy and his horses now moving lively because they were well rested. The loose white dust, that had coated the wagon and the horses during the grinding process, blew in a swirl about us.

On the journey home, my other problem surfaced again like a bad dream. My mother always sent money so that I could pay for the grinding, and then afterwards, she counted the change very carefully, always giving me an example of how money was handled on our farm. She subtracted the nickel that I'd spent

at Hellie's Tavern, like it was one of the day's big business expenses. I knew she would find the shortage, and I knew she would treat it seriously. My worst fear was that she would bring it to my dad and suggest that maybe I could not handle this job, and that I should go back to spending my Saturdays cleaning barns and doing the chores. So the anxiety grew as I drove those horses towards home. I was concerned about losing this more glamorous job.

When I turned on the last dirt trail by District #6, the horses were walking slowly, and I didn't encourage them to hurry. It seemed like there was no way I could escape my mother's reprimand and its unknown consequences.

Then ahead of me a new situation presented itself. It made me forget my troubles. It had rained the night before and the dirt trail, with the grass in the center, was slippery—not to

A Two Row Mechanical Corn Picker, a 20-Horse Powered Tractor, and a New Rubber Tired Wagon. This combination enabled the farmer to harvest about 15 acres a day. A heat house (canvas shroud and windshield) was an optional piece of equipment and considered a real luxury.

an iron wheeled wagon but to a modern car. Not many traveled that road, and the strangers who did were of questionable motives. There was a late model car, a black roadster with the two side wheels down in that shallow ditch. A paunchy, older man signaled me to stop. A younger, uncomfortable looking woman, was in the front seat totally engrossed in reading a newspaper.

The man wanted to see if I could pull him with the horses, but with a look of total frustration, he blurted out, "Christ, you're just a kid!" He was really excited, and he said the woman needed to be at work, and the car needed to be pulled. I told him that if he had

a rope or something, I could pull him. Even though he looked very skeptical, he did find a piece of rope in his car.

I parked the wagon and unhooked the team of horses. This was a challenge, because we had to leave the neck yokes on the horses so they would stay even. We also had to leave the whipple-tree hooked to the horses, and it needed to be carried when the horses were moved, so that it didn't strike their heels frightening (spooking) them. At first the man just stood and watched like it was not going to happen. Then he began to get in the act, helping hold up the heavy whipple-tree as I backed the horses to the front of his car.

PRIDE IN THE NEW CORN HARVESTING COMBINE. This machine combines picking and shelling corn leaving the cobs and stalks in the field for fertility. One person now could do the work of many.

The woman lost interest in her newspaper, and I could see that she was quite young and pretty, though very concerned looking. When she saw me watching her, she grabbed the paper again as another article caught her attention.

We hooked the rope to the whipple-tree and to the bumper of the car, and as he started the engine, I called to Nellie and Beauty. They were good horses and dependable, and as they leaned into the load, the whipple-tree raised high. The rope tightened, and the harnesses stretched, and the rope creaked. Their hooves began to slip in the moist dirt, but they just leaned harder forward, and the muscles in their shoulders knotted as the car began to move. You could feel the tension in the air, just like the tension in that stretching and creaking rope.

Soon the car was sitting on the little dirt trail, and everyone was happy. The man was smiling, revealing a missing tooth. The

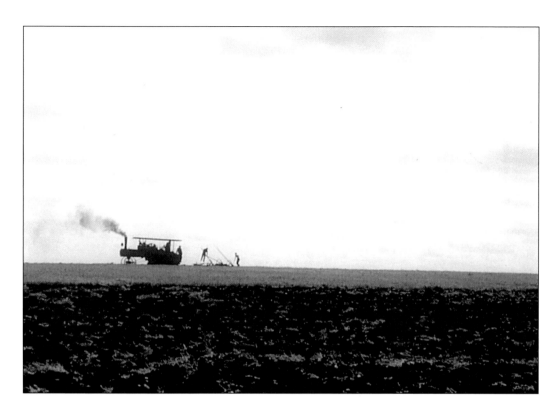

Steam Engine on the Horizon. The smoke from the steam engine, rising into the Southern Minnesota prairie sky, signals the end of an era—the change from muscle power to machine power.

woman, with the newspaper forgotten, also had a big smile. We unhooked the rope from the whipple-tree, and he returned it to the trunk of his car. He moved with great speed and purpose now, like he needed to be on his way, and as I hitched the horses back on to the wagon, I was afraid that maybe he would not pay me anything for my work. We were always taught never to ask for money.

Just before he got back into his fancy car and Skipper and I were to get back on the wagon, he came over and dropped a fifty cent piece in my hand. He told me those were good horses and I'd done a good job. And then he, and a very happy looking young woman, drove away.

I jumped up on that wagon with a light heart. My burden had been lifted. I called to the team, and they broke into a trot, knowing

they were near home and that their job was almost finished. I drove into the farmyard, put my wagon in the proper shed, put Nellie and Beauty back in their stall, and then I fed them. The needs of the horses always came first.

Then I went into the house, put the money on the table, and sat talking to my mother as she fixed me a late lunch. When she had time, she counted the change. I watched her as she counted it again. She looked over the top of her glasses and said, "Did you notice they gave you too much change at the elevator?" I didn't say anything, because I thought words would only make problems. I just waited.

My mother was a strict Catholic woman and always wanted that clear, and she saw an opportunity here to teach a lesson. She had already stepped to the telephone on the wall,

with the two bells and the hand crank, and was ready to call the elevator, when I blurted out my confession.

I told her about the poosh-up, and Skipper, and the candy, and all the things that had happened, and the car, and the 50¢. She stood there and began to smile. Then she put the money away, never returning my part of it.

She always wanted to make a moral lesson and make God part of it. It seemed to me, He always got in on the good stuff and never in on the failures. She said, "My, God is certainly good to you. He always seems to watch over you." And that was the end of that.

My time in history started in 1931, and I remember three methods of harvesting corn that were used until after the Second World War. World War II seemed to be a kind of time warp, and progress on the farm stood still for about nine years.

One of the methods of corn harvest was silo filling, where the corn was cut in September at a very early maturity and the neighborhood gathered and had a silo filling run. All the neighbors got together and took turns helping each other. The corn was cut green with a corn binder and loaded on flat hay racks. Then it was hauled into the farm yard and close to the silo filler. It was driven by a 40-foot belt powered by a tractor. The silo filler chopped the corn into pieces and blew it up with a big fan into the silo.

The second method was cutting the corn with a corn binder late in the season after it had matured. The corn binder bundled about 40 stalks together and laid them on the ground. Then men stood about 20 of these bundles into a corn shock. The shocks were either hauled into the farm yard to be stacked into a big corn stack or left in the field to be brought in in the winter and fed to the cattle. The shocking was hard work because each corn bundle weighed 20 or 30 pounds and stood as tall as a man. The corn shocks that were going to stay out late in the year had to be tied so they did not fall down. There were many jobs on the farm that were ideal for kids and this was one of them. Often after school my job was to go out and tie shocks. This involved putting a rope around the shock and pulling it really tight, then putting a binder twine around the shock as tight as you could get it and then releasing the rope.

The third way of harvesting corn was to pick it on the ear either with a hand husker, a metal hook attached to a leather strap that was buckled to a man's hand, or a mechanical corn picker. The early mechanical pickers picked the corn on the ear and put it in a wagon that was pulled by a team of horses. This caused some problems because sometimes the horses were hit with the corn, and just the sound of the picker made them uneasy walking beside it. Later the corn pickers were redesigned to pull the wagon behind and it became a one man operation. Someone else hauled the wagons to the corn cribs and unloaded them. Ears of corn were always difficult to handle, either to elevate or to shovel. A corn crib was a roofed building, 6-foot wide by 40-foot long, with 1 by 4, horizontal boards spaced about 2 inches apart to allow the wind to blow through to dry the corn ears. The drying process took about six months. From this the ear corn could be either ground or shelled and used for animal feed.

Most farms like ours had a lot of livestock and used most of their corn. Some farms had less livestock and used corn as a cash crop. There was a saying at that time that "Corn is king of the crops," because it had so many uses. In 1949, one of the first years after I started farming with my dad, we had 6,000 bushel of corn on the ear. It seemed like we had corn everywhere.

In the 1950s farmers started shelling the corn in the field with a new piece of equipment called a picker sheller. The ear corn that used to sit in cribs drying for six months, now as shelled corn, had to be dried immediately, and grain dryers appeared. The grain dryers had to move a large volume of warm air through the wet shelled corn. The heat was provided by propane gas burners, and the fans were powered by either tractors or large electric motors. These fans would

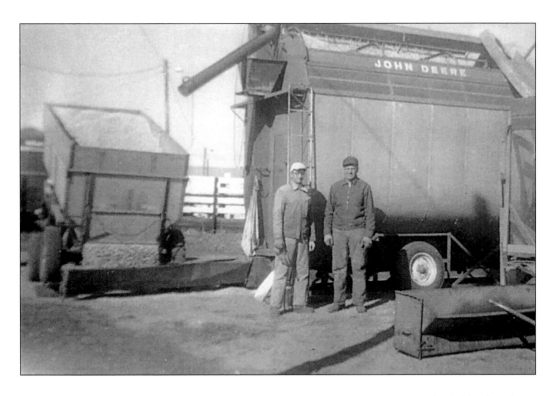

Nineteen-Sixties Corn Dryer. In the 1950s farmers began shelling corn in the field. This dryer forced heated air through the wet corn preparing it for storage.

reduce corn moisture from 25 percent to 12 percent in a matter of a couple of hours. Corn cribs and ear corn pickers gave way to combines that harvested every type of grain. And corn dryers enabled the corn to be stored in large round metal bins.

As the livestock industry became more specialized, the corn shocks and much of the silo filling ended, and the corn all was harvested with combines. Six-thousand bushel seemed like an enormous amount in 1949. By the 1960s we would have had 30,000 bushel stored in less space than the 6,000.

In the 1950s draft horses almost totally disappeared from farms and by the 1960s the individual and his equipment seemed to replace the neighborhood community effort in the harvest operation. The individual, if he was able to afford the machinery, could seem to do much of the harvest as a single unit. In my youth I knew that the neighbors would gather together of necessity to take in the harvest. As I grew into manhood, this way of life almost totally disappeared and the community farmer became an individual producer.

It seemed like every aspect of farming was changing. Some things changed more slowly.

Often at night a little field mouse would run between the soybean rows ahead of my combine. Confused by the lights focused on him, he didn't know where to run or where to find safety. It's a very small incident in the operation of the harvest, but I wanted to write a poem looking at it from both his side and my side. I call it "Pardon Me, Mouse."

First, I see your shadow.
You begin your frantic flight,
Rushing headlong down the row,
In the glare of combine lights.

You look so frail and tiny,
Beneath the frosty plants.
I hope you had time to dress,
Put on some warmer pants.

I wonder for your family.

Draws near the flashing sickle.
Have you no escape plan?

I slow the racing combine,
Before it pulls you in.
You slip into the darkness,
Maybe to flee again.

I wonder, was it your kin,
Running in that same bean row,
While driving my first combine,
Over forty years ago?
The stories passed down to you,
Probably made you feel safe.
Tales of slow old combines,
Mice that ran and won the race.

Each year I wonder,
If yours and mine will meet?
Or has there been just too much change?
You're not able to compete.

Maybe, it will be different,
At some future date.
Yours will be attending.
Mine, the empty place.

I wish for a social meeting,
Not this yearly race.
Maybe sipping tea together,
Or sharing in the grace.

We could talk about this field,
What it means to you and me.

Were they hidden all back there?
Why are you so alone?
What story could you share?

I wonder how you feel.
Whatever can you trust?
Pursued by a lighted monster,
That grinds your world to dust.

When you start to tire,
Your pelt of white and tan,

Make plans for the future.
Talk of harmony.

We have these annual meetings.
You scurry through frosty air.
I watch from a modern combine,
You small and fragile there.

This yearly scene,
Draws from me a sigh.
Can you, a fragile mouse,
Outlast this combine and I?

ELECTION DAY IN AUSTIN TOWNSHIP. Once a country schoolhouse, this humble, unpainted town hall became a place where individual voices count in grass roots government.

After the Storm—Beauty and Solitude. This farm home was built in a large grove of trees as a safeguard from the fierceness of Minnesota blizzards.

Like that mouse, human beings are vulnerable to sudden change.

On Monday, November 11, 1940, a killer storm hit the Midwest. It was always referred to as the Armistice Day Storm. Almost 60 people died that day in Minnesota. The book *All Hell Broke Loose* by William H. Hull is a personal look into the lives of people throughout the state and how they experienced that storm. South central Minnesota is flat and open and the winds swept with fury across our fields and pastures.

I was nine years old, and here's how I remember it. It had been an especially mild fall with warm summer and Indian summer temperatures up into November, and people left their cattle on pasture. We had two herds out and one of the herds was 2-miles away. Because our part of Minnesota is flat land, trees are planted around rural building sites for windbreaks.

Armistice Day started with a rain falling and warm temperatures. Later on in the morning the temperatures dropped and suddenly that rain turned to big soft flakes of snow, and by noon it was snowing hard and the wind was starting to blow. On our farm at that time there were two men working, Hank, a World War I veteran with a drinking problem and bad lungs, and Dick, a young husky man from South Dakota. These two men, my dad, who was 64 years old, my older brother who was 12, and I made up the crew that day. Dick and I didn't have school because of the holiday. My dad was lean and always in good health even though he was older.

I remember as we all ate our noon meal, we could see that the weather was changing. We lived in a protected area with woods to the north and west, and even as we were finishing our meal, before the men went back to work, my dad kept looking out at the weather. He

THE DAY AFTER THE STORM. Minnesota fields in the winter take on the appearance of a snowy wasteland. These abandoned hay rakes speak of warm summer and new mown hay.

finally said, "Boys, I think we should go after those cattle on the south pasture." The south pasture lay a mile south and a mile and a half west of our buildings.

My brother Dick and the two men were dispatched to go first and find the cattle and start them coming towards the farm place. My dad and I were to go a little later because he was older and I was young. It was hoped that they would have the cattle rounded up and started for home when we met them.

I need to explain a little about that time. People did not buy things because they wanted them. They bought because they needed them. Our work overshoes were meant to last for two winters. By the second winter there was no tread on them and it was very hard to stand up in slippery snow. That was what I was wearing as my dad and I started across the field.

When we got out away from the trees, we were shocked at the intensity of the storm. The temperature had dropped so fast and the wind was blowing hard. We were walking south so the northwest wind just propelled us along. Talking was almost impossible as the wind seemed to want to tear the words right from your mouth, and it was hard for me to keep standing because my overshoes were so slippery.

The wind propelled us well for that first mile going south, and as we turned west, facing into that wind, it was hard to catch our breath. The visibility was only a short distance and we had to cross a swamp—a wet area with tall grass and some brush. It was difficult walking and I remember being kinda scared. After we crossed the swamp I didn't see the cattle, but I heard them.

The herd was made up of about 30 cows with calves who were frantically trying to keep track of each other, and they were calling to each other as they went along. The men chasing were barely visible in the snow, but we all took our positions around the herd and pushed those cattle to the east. As

85

we crossed the swamp area the cattle started milling, trying to find shelter in that brush and tall grass. It was hard to move them and it was hard to see them as they tried to take protection from that wind. I remember just screaming at them trying to make them keep moving, but my screams were lost in the wind. I was falling down a lot and getting wet, and I was very tired.

We finally got them out of the swamp and moving east to a fence. When we came up against the fence, I remember my dad and the men trying to figure out where we were. The cattle would have to move north along the fence and against the wind. They absolutely refused to do so, and kept pushing us toward the south, wanting to run with the wind. We hollered and pushed, but they would not go. One of the men had a wire cutters with him and after some struggle, he cut the fence and we continued on east with the herd.

By now it was almost like night, even though it was about three in the afternoon, and it was hard for us to keep track of each other. It seemed like we went east for a long time and by now we had lost our sense of place. Finally we came to another fence. In the snow it did not seem as though it should be there, but if it was the right fence, we knew we should be one half mile south of our barn. The cattle refused to turn into the wind and they kept pushing us backwards. The storm seemed to tear the yelling from our mouths and it was quite an eerie place.

Finally one of our cows had a sense of where she was. She put her head down almost to the ground to protect it from the wind, and started towards home. She was a true leader and we somehow got the others to follow. I remember I was so tired and when I fell down again and even though I was cold and wet, I thought I would lie there a moment and just rest. Suddenly out of that blizzard my dad was standing over me with his big walking stick raised. I couldn't hear his words in the storm but I knew I was to get up or he would hit me. He made it very clear that I was not to rest.

The cattle followed that one cow and continued north against the wind and we were pushing them along and keeping them from turning back. Because the storm had started with rain and then changed to snow, the cattle all had ice frozen to their coats, and in that blinding snow, it gave them a very ghostlike appearance. After endless time and in total darkness now, it seemed like the wind lessened, but we had no idea where we were. Then the cows refused to move any further. Because we were all at the back of the herd pushing them, someone had to walk around the herd to see what had stopped them. He came back with a wonderful report. We were up against the barn. The barn door was opened and lanterns were lit, and the herd began to file through the door—the cows and calves a bawling.

When I first told this story, I did it in a poem. It went something like this.

The snowy white ghosts,
With their ice covered coats,
Filed into that warm lantern lit barn.

I still remember in the shelter of the barn, their icy coats made it sound like they were all wearing beads, and as they were separated into pens and started to be fed, my dad said the most welcome words I ever remember him saying to me. He said, "Mike, maybe you should go to the house." When I wrote that poem, I ended it like this.

For a hundred and twenty five years,
We have lived on this farm,
Where many have given their best.
I think the reason,
We still call this home,
Was that storm,
And how Dad handled that test.

CHAPTER 4

Winter

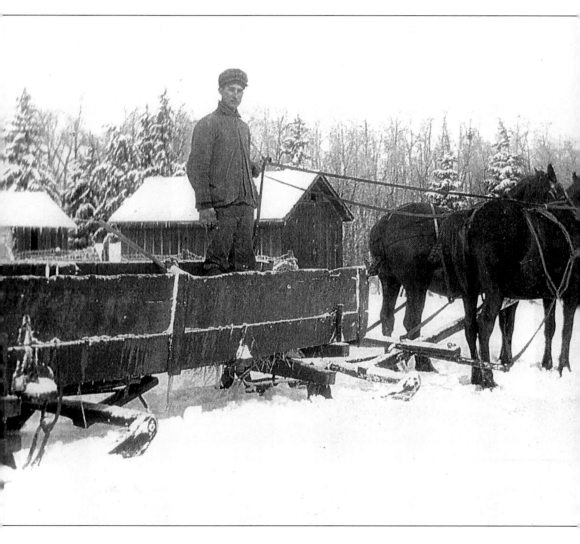

WINTER "CHORSS." When farmyards were drifted full of snow, a farmer depended on his bobsled and a good team of horses for hauling feed to the livestock, bringing hogs or calves to market, and for hauling manure.

There's an 80-acres west of Austin, and when I first started telling this story a few years ago, I checked the title in the Mower County plat book. I was surprised to see it still bore the name Anna Gerhart, for she had been dead many years. It's like she had put such a strong mark on that land, that no time or person could erase it.

In the 1930s and 40s, Anna was a poor widow in our rural neighborhood. She lived on a tumble-down farm of unpainted buildings, and there was a sagging front porch on her house—a porch where unusually colored chickens sat on warm spring days, facing south to the road we traveled on our way to Austin. Chickens on the front porch was a sign of poverty in those days. And chickens, the unusual and bright and colorful species of Mrs. Gerhart's, spoke of no organized breeding program whatsoever, but just survival of the fittest.

Mrs. Gerhart often seemed to be walking down the road, wearing a long black dress, and old-fashioned, high-button shoes and with her head covered by a turban. She had the graceful stride of a greyhound. It was the proper and Christian thing to do to pick up Mrs. Gerhart when you were driving to town.

Years later I wondered why I was so fascinated by Mrs. Gerhart. I think it was because my father shirked some of his parenting responsibilities. In the mid-30s my mother's youngest brother got married, and although I did not attend the wedding, I heard so much about it and how beautiful it was. It seemed to dominate our dinner table conversation for weeks and weeks, and I could only imagine what such an event must have been like.

In a moment of six-year-old honesty, I confided to my dad that I would like to get married. Instead of seizing one of those wonderful opportunities to have a heart-to-heart talk with his son (an opportunity that parents never should miss), he just laughed and said he thought that would be a good idea. I could marry the Widow Gerhart down the road. We could have a little ceremony, and I could move right over there. "The place needs a good man," he said, "There would be plenty of work to do there."

I was shocked. She had no more than five teeth, three of which were gold and I thought her face looked frozen. What I had in mind, was my cousin who lived in St. Paul, who had long dark hair and wore pretty dresses. I think it caused me to observe this widow lady, when the rest of my family joined in the fun and called her, "my lady friend."

On a chilly, Saturday morning about November, as we would be going to town to do our shopping, we would often pick up Mrs. Gerhart on the road. Her cars quit running in September and she usually didn't get them running again until May. So it was typical on a chilly Saturday morning on our way to Austin, that we would see her walking ahead of us heading for town, with her long stride, her turban on her head, and her long black dress flapping in the wind. I've heard there were many layers of black dresses depending on the temperature.

We always picked her up, as did most people. It was the proper thing to do. She would get into our car with an upbeat attitude. With her would get in many smells. Her winter custom was to heat only one room of that cold house. So there was the smell of the fried food, and the smell of all those pets that shared the room with her, and the smell of the oil stove that heated that one room. There was also the heavy smell of the barn where she had taken care of her "chorss" that consisted of some chicken chores but mostly hogs, or as she said, "hocks." But all that work was behind her as she got into our car, upbeat, heading away from that cold place, "chorss" all done until Monday, and going to visit her friend Isabel, who had a little neighborhood grocery store and central heat. There she could be some help and enjoy herself over the weekend, and she was happy. She talked steadily and I noticed those five teeth, the gold ones speaking of a more prosperous time. They just seemed to be swinging out as she spoke. I marveled at how she could have her chores done until

Free Ranging Hogs. Some farmers raised their hogs in the open with only a minimum of protection from the weather. In this picture, the hogs are still using the one building remaining on an abandoned farm site.

Monday, because we had to be back in the afternoon to do our chores for the second time that day. A few years later we bought some of those "hocks." They were some wild animals, half-starved and ferocious looking. They made Arkansas razorbacks look like household pets by comparison. Mrs. Gerhart called on everyone. She had no phone and no car, but she always seemed to know what was going on in the neighborhood. She accomplished this by making long visits.

After we got our new house in the early 40s, Mrs. Gerhart would visit us to make a phone call, walking two and a half miles against that sharp northwest wind. I remember one Christmas season when my oldest sisters were home from college, and my mother had organized all of them into a cookie and candy making brigade. My mother's Christmas gift list never seemed to get shorter. Instead it got

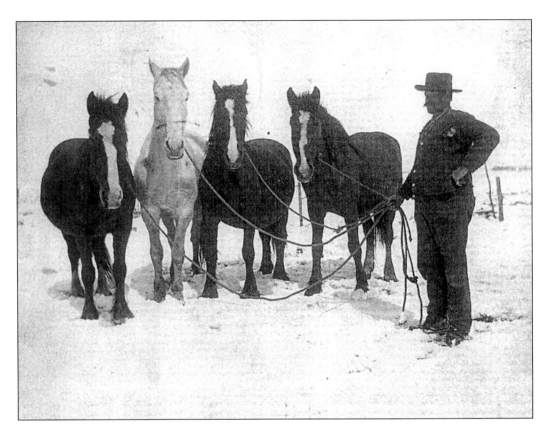

Horse Trading. The words "horse trader" always meant buyer beware, and farmers often bought their horses in the winter so they could try them out or retrain them with a bobsled.

longer, and she was having three reluctant girls working industriously packing boxes.

Her list consisted of older relatives who had no one, as my mother said, "people who need some Christmas cheer." There was also a couple of people who our dog had bitten and had caused no trouble, and even someone whom our dad had bumped with our car and maybe dented a fender and the incident had been settled peacefully. It was easy to get on the list and hard to get off.

One Saturday morning, my mother was really rolling, having this all organized and moving, when through the window she saw Mrs. Gerhart coming across the yard. At times like this she would say in a frantic voice, "God help us. Here comes Mrs. Gerhart," in a prayer that sounded like profanity. But she

was a Christian woman and she would go to the door and say, "Welcome, Welcome, Come on in." Mrs. Gerhart would come in talking, shedding endless sweaters and shawls, soon to be sipping hot tea and eating fruit cake, and feeling the excitement of coming out of the cold into this warm house.

I always marveled that those five teeth seemed to swing out there, independent of all those projects. Pretty soon Mrs. Gerhart would be telling the stories of the men in her life.

They were always the same ones, and we frequently heard the one about her late husband Will, or "Vill" as she called him. Vill was an absolute saint of a man. He was a wonderful farmer and he had no faults. He had been dead for quite a while. She told that

old story again about how he had all of these hogs. How he had accumulated enough of those "hocks" as she said, so when he hauled them in one Saturday in the winter, he had enough to pay off the mortgage on their farm. How he had hauled hogs all that day with the horses and bobsled, load after load, until he had them delivered to the Hormel Packing Company. It was dark when he finished hauling those hogs, and when he received the money for them, he didn't want to take it home. He wanted to put it in the bank so it would be safe—to make them debt free on the first of the week.

With the lantern hanging from the metal hame on the horse collar, Will drove downtown to the bank that he knew would be closed, and looking through a back window, he saw a man in there and got his attention. The man opened the front door of the bank and took Will's money. After the deposit, Will went home happy, knowing that he soon would be debt free. The bank never opened on Monday, and Will didn't live a year after the bank failure.

Mrs. Gerhart would start crying then and tell how the bank had killed Vill. Then she would sort of pull up her spirits again, and get that upbeat attitude and tell how her life was going to improve once Matthew graduated. When "Mattchew crachuates," she said, "the farm will be powerful again. He will be a wonderful farmer like Vill" and she will no longer be the poor widow of the neighborhood. Later on she would roll her eyes and worry that Matthew was hanging out with those Hubbard boys who wore leather helmets and were riding motorcycles. I remember them as noisy old motorcycles with the shift lever on the side. Mrs. Gerhart wondered if this was the proper environment for Matthew to grow up in. She worried about whether or not he would graduate and take over the responsibility of the farm.

In our community there would probably be two parties over the course of the winter. The neighbors would gather at one house or another to play cards, have lunch and visit. When they weren't playing cards or having lunch, the men were usually in one room and the women in another, so each group could talk about the things that interested them. This put Mrs Gerhart in an awkward spot, because she was a proper woman of her time, and yet she wanted to listen to the men's conversation in the hopes of picking up a tip for managing her farm. So she was often an odd sight as you would see her hovering outside the door listening as the men were talking about farm business.

One night at a party it did pay off for her. She got a wonderful idea as she overheard Steve Lickteig, a young and progressive farmer, discussing the purebred, fancy male hog he was shipping in from a southern state. He had a fine livestock operation, and this fancy hog would only improve it. Mr. Lickteig was so progressive that it was said he sat in the house in the winter reading farm magazines and he hired a neighbor to do his chores. I suggested to my dad that we should follow that operation and get more knowledge. He said that was "damn foolishness," that "everyone should do their own chores."

Mrs. Gerhart thought that what was wrong with her operation was that the hogs didn't have the right breeding. So even before the fancy hog had arrived, Mr. Lickteig got a fateful call. "Mr. Liktak," Mrs Gerhart said on the phone, "Can I please borrow your male hock?" It was a terrible decision for him. The choice between letting that hog go into sure disaster or being blackballed by the neighborhood for not taking pity on the poor Widow Gerhart. Mr. Lickteig made the right choice and when the fancy hog came in on the train, with a heavy heart he hauled him to Mrs. Gerhart's and dropped him off.

In a very short time, he got another phone call from Mrs. Gerhart saying, "Mr. Liktak, I am tru wit your male hock." He was overjoyed that she was finished so soon, and with a team of horses and wagon, he went over and picked up his male hog. And he placed him in a special pen where he had only the fanciest feeds and the best of care. After a few days he turned the hog out with his well-fed gorgeous lady hogs, only to see his fancy male

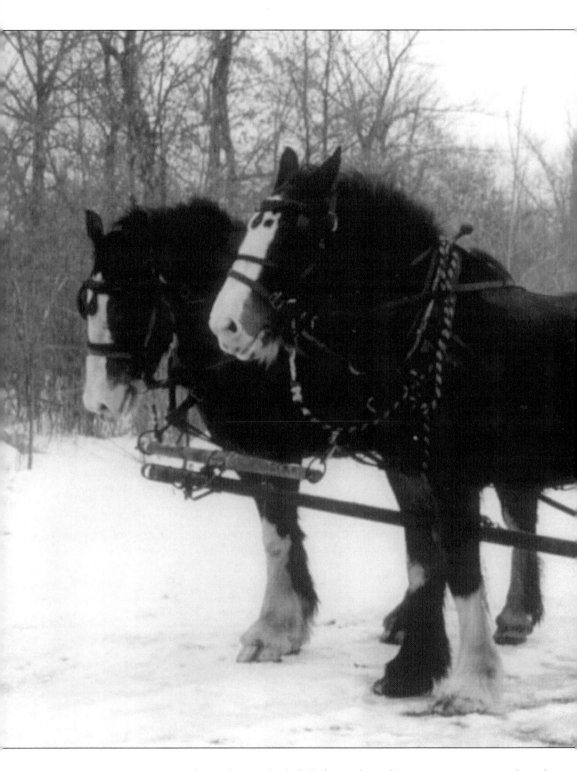

THE ALL-PURPOSE BOBSLED. *In the early 30s, the bobsled was the only way to get to town when the roads were drifted. This triple box sled, which normally served to haul feed to the livestock,*

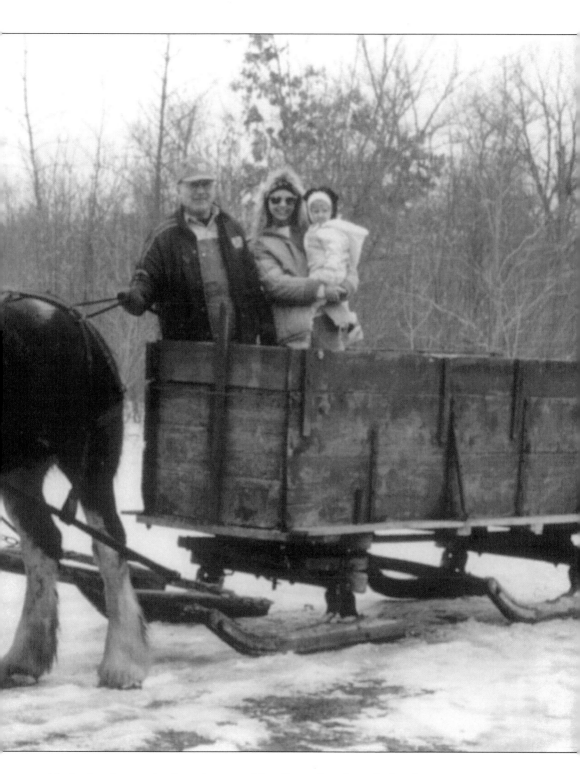

could also haul groceries from town and family to church and school.

hog go over in a corner and look out through the fence as if he were pondering some deep and unsolvable problem. If he mingled at all with those lady hogs, it was strictly in the roll of a consultant.

Mr. Lickteig did a drastic thing. He called a veterinarian and had the hog examined. The results of the examination were so upsetting to him, that he drove over to see my dad immediately. When Mr. Lickteig lowered his voice, signaling this was not fit for the ears of women, I leaned forward knowing that I didn't want to miss anything. Apparently when Mr. Lickteig got the results of that examination, on the drive over to see my dad he lost the medical term, and as I tried to reconstruct the misfortune, it seems that on a purebred male hog's anatomy, there's a very important part. It's not a major part, but it's an important part. Hogs are sort of like people, in that each one sees things differently. And what one of Mrs. Gerhart's half-starved lady hogs had seen as romance, another had seen as fresh meat on the table, and had "run off with the trophy," so

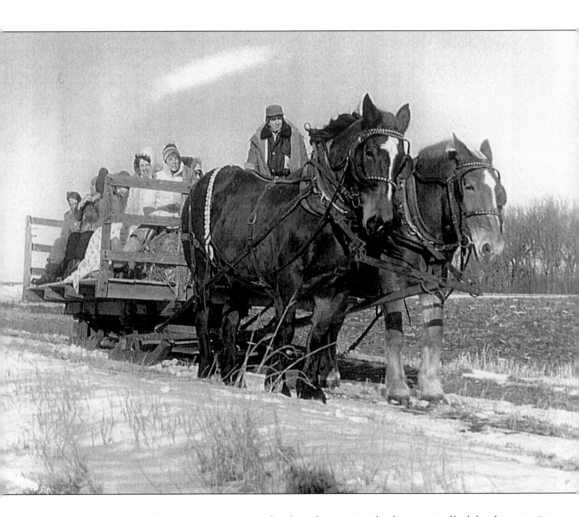

THE BOBSLED TODAY. *Everyone enjoys a sleigh ride, particularly one pulled by horses. For children, it's a new and exciting experience, and for the old man, it's a memory of when the horses and the bobsled were a vital part of the farm.*

to speak. That male hog did have a deep and unsolvable problem, and he had every reason to stand and ponder it.

Now I'm sure there's a scientific name to describe that situation, but Mr. Lickteig had lost it in the excitement, and in his lowered voice he informed my dad and I, "That hog has no more tool than the man in the moon." And no veterinarian would give a diagnosis like that.

Little did I know, that incident would ruin my first date on prom night a few years later.

After the dance we all gathered in Todd Park. The girls in long dresses, the smell of perfume blending with blooming lilacs, and a full moon all made for a romantic setting until someone thought they saw the face of the man in the moon. I, of course, kept flashing back in my mind to Mr. Lickteig's pig and his deep and unsolvable problem.

A few years later a knock came on our door late at night. On a winter night out in the country, it's unusual when people knock on your door. Matthew Gerhart came to the

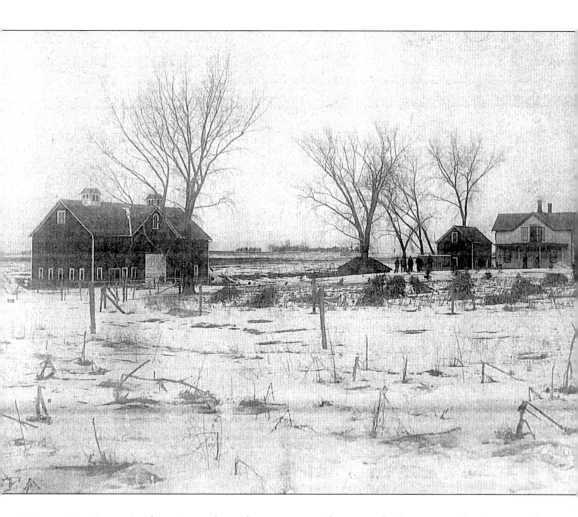

WINTER FARM SCENE. *In the winter, the only two warm places on the farm were the house and the barn. These corn shocks, probably frozen in the snow, needed to be hauled in and ground up for cattle feed.*

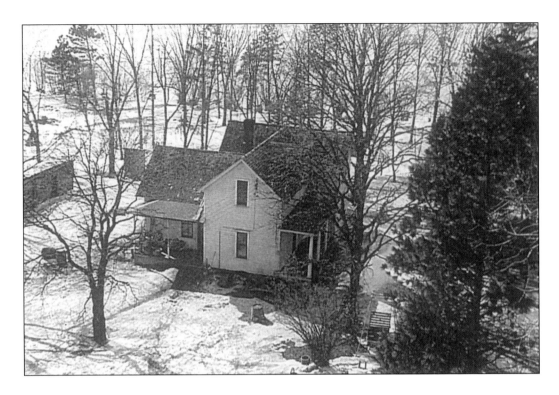

Typical Southern Minnesota Farmhouse. This wood frame home was built about 1890. The grove of trees and the small number of windows provided protection from the cold winter, and porches offered coolness on a summer evening.

door in his army paratrooper's uniform. My dad got me up to be part of the discussion. He always wanted me to be a part of the business of the farm. Matthew wanted some papers signed by my father stating that he, Matthew, was his mother's only means of support. He had volunteered to drop behind the German lines to help end the war, and with these papers, the government would take care of his mom whether or not he returned from the mission.

To make sure the papers were signed properly, he had slipped out of camp and hitchhiked through the night, which was very serious business in World War II. My dad said that he would take the papers to a lawyer and see that they got signed properly. And then he told me to get the car and take Matthew back to the highway. My last vision of Matthew was of him starting swiftly down

Highway 16 with his thumb out trying to flag a ride. Matthew had truly graduated and his mother didn't even know it.

Before too long, Mrs. Gerhart's lot changed. With monthly income, she soon got a better car and we no longer saw her walking on the road. Then she moved to town and I lost track of her. She's been gone for many years, and now Matthew lives on the home place. It's all totally neat, because he was a carpenter, and he kept some of the buildings the same design as they had been years earlier.

Now when I drive down that road on a chilly morning, in my mind I still see her—a tall woman with a long black dress and high-button shoes, a turban on her head and taking those long strides, her "chorss" all done until Monday, going to visit her friend Isabel where she would be nice and warm, and I wonder, "Was Mrs. Gerhart really poor at all?"

In that era winter trips to town often meant travel by bobsled, which was an important piece of equipment on the farm. When I see a picture of a man standing in a bobsled with a team of horses that looks like they've worked a lot, it makes me remember how bobsleds were used and their roll in my life from the 30s to the 50s.

On our farm we had one bobsled, and it always amazes me that at the end of the bobsled era, we got another one. If ever a farm had needed two, it was ours. We always had at least two teams of horses in the barn that were our winter chore horses. The other draft horses were turned out in a sheltered yard and fed hay, but these two teams were grain fed and kept in shape. Our farm was a busy farm with many animals: horses, cattle, hogs, and chickens. In my young life we'd have two men who were wintering there and doing chores. We had an iron-wheeled wagon that was used to haul feed for the cattle. In my mind I can still hear those iron wheels squeaking on the cold snow. But the bobsled could go anywhere.

I don't know the origin of the bobsled or why it was called "bob," but that sled could go over or around snow drifts. Wherever those big horses could walk, it could follow, and when the roads were just impassable, and our car, even with the chains on it, couldn't make those four mile trips to town, then the bob sled had to go to bring the older kids home from school. Because I was the youngest and not yet in school, I waited for them to come home, and on a bright day I would look down that east road, a mile and a quarter, and see that bob sled coming in the distance. I would bundle up in my heavy clothes and run down the road so I could meet the sled as far from home as possible. The wind would bite my face as I ran, but I wanted the chance to drive those big horses. I remember those horses' hooves kicking up snow as they trotted, and the frost on their whiskers and nostrils from the trip. When my dad stopped and helped me get on the wagon box that was on the sleigh, I would see my sisters huddled under blankets. My brother often ran behind the bobsled just to keep warm.

I, of course, would ask to drive as soon as I got on the sled. I was probably nearly five years old, and knew I should be handling some of that responsibility. My dad would give me the lines and caution me about running the horses too fast so they'd get overheated on a cold day. I would call to those big horses that were my friends and they would start running for home. The horses were anxious to get there, and I was proud that I could drive them running like that. Plus, I had a captive audience, bundled in the back. The highlight of my memory was my sister telling me that I drove the very fastest.

The bobsled could be fitted with either a box or a rack. The narrow wagon box used to haul grain and feed was called a triple box because it was three boards high. Each board was about 15-inches high. The flat hay rack, which was about eight feet wide, had the sides taken off for winter work. In the winter the rack was removed from the wagon wheels by hand and lifted over onto the bobsled. It took four men to lift the heavy box on the rack, but usually there were only two men available to make the switch. The rack was used for hauling corn shocks in from the field or from the stack in the yard. It was also used to haul straw from the straw pile to the barn for bedding the animals. When the weather got very cold the rack was used to haul the manure cleaned out from the barn onto a pile in the field to be spread later in the spring. Work had to be planned ahead to minimize the changing of the triple box and the rack.

Frustrating days were those when the roads were impassable and the car was unable to make it. Then the rack had to be taken off of the bobsled and the box put on to go to town and meet the kids from school or maybe to get groceries. The box was cleaner and it offered more protection from the wind, which is why it was put on to go after the kids. Fresh straw was also put in the wagon box. It not only was warmer for my sisters, but it covered some of the smells that the wagon might contain.

My dad often told the story of when

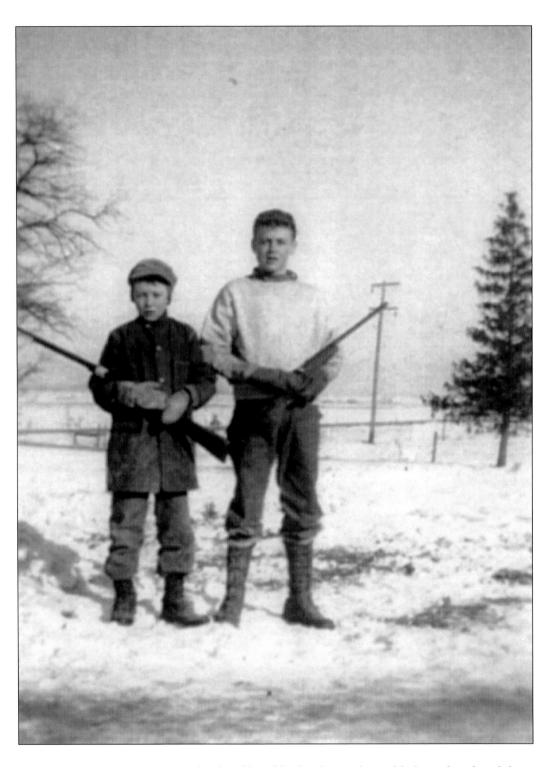

Brothers. A year after the fire, Michael and his older brother Dick would often take a break from Sunday chores and do a little hunting or trapping for entertainment and spending money.

diphtheria came through the country about the turn of the century, claiming the lives of many young children. He talked about one winter funeral where the bobsled and rack was the only way to haul the casket to the cemetery. My dad was one of the six young men who were pallbearers and had to walk beside the bobsled trying to hold the casket as the sled went over the snowdrifts. He told of how at times the bobsled would tip and the casket would slide off into the snow. Mostly he remembered the sounds the mother and the family made when this would happen.

The bobsled played an important roll on our farm and in our history and it certainly was an important implement in my young life.

In the early 1950s, with the coming of the tractor front-end loader, the farmyards got cleared of snow and the modern snowplow kept the roads open. The bobsled quickly disappeared from farms and was used only for entertaining young people on sleigh rides. The bobsled had a very long history, but the history ended rather quickly once it was no longer the main farm implement of the winter.

My dad was comfortable with the horse era. He never liked machines very well, because he never really understood them. His 1936-G John Deere tractor was different. It seems like they understood each other. One thing he liked to do was to have that tractor grinding feed on Saturday. With the long belt coming out of the granary, and the old John Deere banging away out there, loads of snowy corn bundles and ear corn could be ground for the week's supply of feed. It was a Saturday ritual he loved and I hated, because it meant a lot of cold work and a dusty windy granary. Because of this ritual, we had one of our most memorable Christmases.

It was a Monday in the middle of December, and because of a blizzard, we could not make it to school. When my dad realized the roads were blocked, he immediately assigned jobs to everybody. With the heavy snow, a lot of shoveling needed to be done. Gates and doors needed to be shoveled open, paths needed to be shoveled to the different buildings, plus the animals needed care and feeding.

We had two men working for us at that time. One of them named Hank, a World War I veteran, had not made it back from his weekend celebration in town. So as we went out to work in the barn, there was my dad, and Dick Boughten, a husky eighteen year old from South Dakota, my older brother Dick who was twelve, and myself, nine years old. When dad saw all the help he had, he decided we probably should start that tractor.

He had found that on cold nights he should drain the oil out of the tractor, and let any moisture that was in it freeze. He then poured the cold oil in a bucket, and in the morning, he would bring it in and set it on the back of the cookstove for an hour or two. When the warm oil was put into that tractor, it would start right up. That day the oil was placed on the stove real early in the morning, and we were all in the barn doing our chores. Outside the barn a blizzard was raging.

All of a sudden my older sister was outside the barn door screaming, "The house is on fire. The fire is in the kitchen." We all grabbed shovels and ran through the snow toward the house. I will never forget the sound of windows being broken, and as snow was shoveled into the house, the smoke poured out.

There was such a large amount of snow and frantic shovelers, and the fire was quickly beaten back. I can still picture all of us standing in that blackened kitchen, pools of oily water and piles of snow on that uneven linoleum, and my mother trying to figure out how she could ever get a meal on.

It was like the lull before the storm, because we soon heard crackling above and knew the fire had followed a chimney upstairs. Dick Boughten ran to get a ladder and climbed to the second story window. When he broke the window to crawl through, smoke poured out. He went into the house and we didn't see him for a short time, and then we saw him hanging out the window, coughing and gasping for air. They had to give up on the

second story where all of the clothes and bedding were, and then try to get the most important things out of the first floor.

My brother Dick was sent to the neighbors through the waist deep snow. My mother stood in the little entry cranking the emergency fire ring on the old wall phone. I can still feel the fear as I heard her screaming into the phone, "Our house is on fire." My dad and Dick Boughten tried to move the huge old upright piano out of the living room. It would not go through the door or the window where I'd tried to remove the sill with a bar. Because the house was burning from the attic down, it was a mass of flames on top and yet we could move in and out of the first floor. My sister Therese was crying and screaming for us not to go in that house.

A couple of neighbors arrived and helped to carry things out. Everybody came on foot because of the storm. One person rode a horse. They came through the snow from about a mile and a half to two miles away. The house was totally in flames when I saw my brother Dick was back, and he and I crawled into that house underneath the smoke to rescue his trumpet and a jar of money he had hidden in the dining room. The black smoke was about four foot above our heads as we crawled along the floor. I remember the sounds of crackling up above us and the confusion of wondering where I was in that house. By the time we got his trumpet and money, burning sticks were falling down and I was scared. We had to crawl very close to the floor because the air was still cool there.

Everybody was now back by the chicken house because the heat was so intense. Much of the furniture and articles that had been brought out were set too close to the house and the heat of the fire destroyed them. The neighbors and family were huddled together watching the house burn as the snow fell. We were all safe and had fought the fire the very best we could.

After a few hours, we moved over to the bunkhouse. The bunkhouse had two old beds in one room and one heat stove. There was another room filled with junk and an upstairs loft. The building was not insulated. By the time night came, a neighbor had brought a bed and a cookstove over, and we had cleaned the empty room out and made it into a kitchen. I have no memory of that night. My brother said it was the worst night of his life. As he and my dad and I slept in one bed with our wet clothes on and my mother and sister in the other. Dick Boughten slept in the barn in a manger with a sheepskin coat wrapped around him. I think we were all afraid and totally defeated. To this day I never go to see a house fire.

We didn't attend school before Christmas because we only had the clothes we were wearing the day of the fire. I'll never forget the feeling of realizing the only clothes I had were the ones I had on. In the days that followed the cows still had to be milked and fed, the animals had to be taken care of, the barn still had to be cleaned and bedded and life had to go on.

My sister stayed in town at my Grandpa and Grandma's, but my brother, my dad and mother, and I all stayed in that bunkhouse on the farm. Dick Boughten and Hank, who came home a couple of days after the storm, slept upstairs in that loft. About three days after the fire my brother and I moved up there too. I remember the first night I was there, seeing the stars through the peak of the roof where the shingles didn't quite fit right.

My mother made one great discovery. During the fire, someone had thrown several pounds of butter out into the snow, and they had frozen, and in the cellar, the whole bin of potatoes had cooked. For days we had hot steamed potatoes and butter, and I remember how good they tasted. Some carpenters came and started putting insulation upstairs and people brought us extra beds.

Christmas came to the bunkhouse that year, it was 1940. I remember my brother and I hung our stockings without really expecting anything. And on Christmas morning my stocking had an apple and an orange, some wonderful hard Christmas candy, and peanuts in the shell. There was one wrapped package

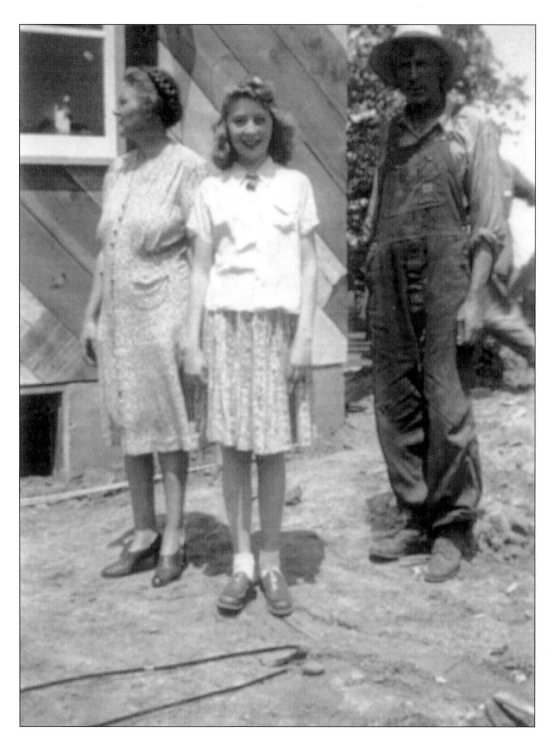

The New House. Richard and Rose Cotter are pictured with their daughter Therese. Because they believed in the future of the farm, they built a beautiful new home to replace the one lost in the fire.

to be opened, and I was hoping against hope it would be wonderful. It was a suit of long underwear, a union suit, extremely necessary but not really what I had in mind.

With a cookstove, the bunkhouse had taken on a home atmosphere, and for the first time we were going to try to go to church that Christmas Day. With the Christmas candy and gift opening out of the way quite early in the morning, we had to get the chores done. Then, with make shift clothes, we headed off to church and to my aunt's house for Christmas dinner. My dad liked to eat there, and I thought her house was elegant. She

was a math teacher for years, and she had never married. We were led to believe that she liked children to be well behaved, so we had to be very quiet at her house. She always gave me a pair of long stockings with a 50¢ piece in the toe of one of them. I always gave that money to my mother to hold. As I recall, it was the last time I ever saw it. I think my mother taught me a lot about where to bank your money. After the very pleasant meal in that somber household where all the talk was about the fire, we were finally allowed to go to my grandparent's home where there was much laughter, bright lights, and at least one

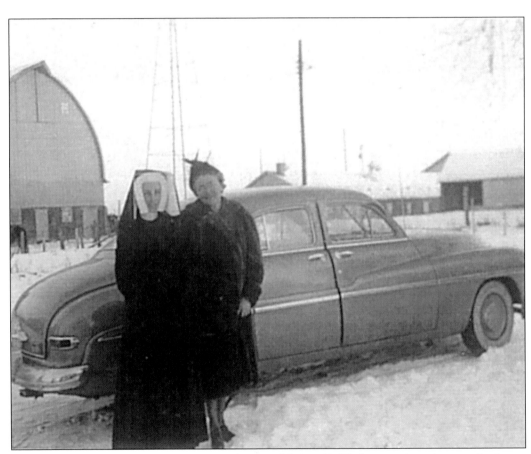

Mother and Daughter and the New Car. After World War II, life began changing on the farm. This was a time of transition between the 20 draft horses and the second tractor. The Cotter name was on the waiting list for a year before we got the 1949 Mercury equipped with a radio and white sidewall tires.

cousin. At that house, gifts were actually given to kids like candy bars and wonderful things.

It just seemed like minutes until my dad announced we had to leave for the farm. This was before there was electricity on that farm and much had to be done before dark. I'll never forget coming into that cold bunkhouse with both stoves out, and then slipping into those cold barn clothes. We had to get right out to the barn. Lanterns were hung on the rafters of the barn and all the animals were taken care of. The animals were happy to see us and the cows strained in their stanchions reaching for the feed. The barn was warm from the heat of the animals and soon we were caught up in bringing them Christmas. We finally got all the chores finished, and as we were carrying the lanterns towards that bunkhouse, I knew the fires burning in both of those stoves would have that house warm.

The smell of cooking food and wood smoke was in the cold night air. Walking toward that bunkhouse, anticipating the warmth and good food, we all knew how necessary we were for that farm. It was a most unusual, but a not-so-bad Christmas.

Long after the fire was over and almost forgotten, at a party one night, one of my uncles said that he never realized my dad had such a love of music that they would spend all of that time trying to get that piano out, especially since no one ever played it and no one could remember when it was last tuned. The other kind of funny thing was, because there was some insurance on that house, everyone seemed to forget that a bucket of oil had been set on the stove and probably exploded. No one ever knew for sure how the fire started.

Growing up on that Minnesota farm in the 30s and early 40s, in all seasons our roles as boys and girls were very much defined. If you were a boy you worked in the fields and the barn, and if you were a girl you worked in the garden and the house.

In the winter, the barn and the house were the only two warm places and each had a life of its own. When I was about twelve, one late February day after a particularly cold winter, we were treated to a special morning, and even though it was early, the sun was coming up bright and the air was perfectly still.

Though the ground was frozen, the stillness of the air let that late February sun, with its strong rays, give a promise of spring. It was a wonderful day to just stand out and look around that barnyard. Our big slaughter cattle, that weighed twelve or thirteen hundred pounds, had moved out of the shed, where the ice was thick on the walls and the frost hung from the ceiling, and were now standing in a row where the rays of that February sun could seep into their thick coats. They were standing quietly like they were in meditation. It was a very peaceful scene.

Suddenly a tremendous racket came into that feedlot. A small hen, coming from a chicken house a long distance away, seemed to be running for her very life. She flew up on that high board fence, paused just a moment and then flew again landing on the back of one of those steers. His meditation was shot. He didn't know what was on his back or how to get it off.

Not far behind this hen, the sun reflecting off his beautiful plumage, an old king of the flock rooster, with a bright comb and bright red waddles under his chin, came in hot pursuit. His day was not going well. It had been a long chase and he was already overheated, and though I was a young boy, I could see that his heart was full of lust. And I knew that was a serious situation, because our family attended parochial school where this was often discussed. This was a drama I had seen many times.

Now this whole program has been moved to the schools with the overhead projectors and the diagrams and the arrows all telling the story, and I believe it's called "Family Life," but back then that program was still in the barnyard.

The rooster, too, flew up on that board fence and then he flew down on the other side in a brilliant reflection of the sun on his plumage. He did not know where the little hen had gone. He was acting arrogant and

obnoxious and you could see he was on a real tight schedule. Then he saw her sitting up on the back of this steer, and even though he went over and stood right behind the steer, he still had a problem.

Now that steer, who was fidgeting around, of course had never attended parochial school. But he had some other problems. One was he never really intended becoming a steer. He had another vocation in mind, but on an otherwise uneventful day, he had been run into a chute and had his personality changed forever. And it was not his idea. But it might explain why he was into meditation the way he was.

As a 12-year-old boy watching this, I thought it was such a mismatch that I picked up a stick and threw it at that rooster. And even though it did not even come close to him, he was so dramatic that he gave a loud squawk and flew up into the air right back of the steer. Now to this frustrated steer, who had had his meditation ruined, this was the last straw, and he kicked.

In a rare moment of timing, this blow that might have broken a man's leg, connected with this despicable lust filled rooster in mid-air. And there was a pretty good puff of feathers right there. There was a much larger cloud of feathers when that rooster crashed into that board fence 10-feet away, and he slid down that fence and onto the ground like some character in a Walt Disney cartoon. That beautiful plumage folded over him like a mantle, and I thought he was dead.

But he was not dead. He got to his feet and they were not steady. He in no way resembled that rooster of a minute or two earlier. His head was low to the ground. His tail feathers that had reflected the sun now hung colorless near to the ground, and he couldn't even recall why he had come into that feedlot. He knew he wanted to run, and he didn't have to fly over that board fence. There was plenty of room underneath. When I last saw him, he was running with long steps back to the chicken house. The little hen hopped off the steer's back and continued her morning.

Taking some poetic license, I tried to imagine the future of that rooster. I could see him coming to the chicken house, all stiffened up, trying to fly up on that roost where they slept and regain his stature as king of the flock. I could imagine a young rooster looking down on him, and in a squawky teenage voice, saying, "What happened to you? You look terrible." And that old majestic rooster riveting him with a look of distain, and in a hoarse voice saying, "By God, you won't believe the day I've had." Or he might have kept his fine plumage and become like the pope, going from chicken yard to chicken yard, preaching celibacy as a way of life.

I believe there was more drama in those barnyards years ago, before farms became so specialized, with all those different kinds of animals there together working out their relationships.

I graduated from high school in 1949 and started working full time with my dad. He was 73, in good health, and with a strong will. This was shortly after the Second World War ended. In 1949 you could get machinery by putting your name on a waiting list, as industry was changing over from wartime to peace time production. Prior to that you'd sign up on a waiting list, but never get the machine. The farms had all been held in a state of no progress during and after the war years.

There was quite a struggle going on between my dad and myself. I wanted to modernize and get some labor saving equipment, and he sort of had his old age planned. It would be the way it always was, though he would not have as much work to do. He would just help. He did allow some change in the crop and field equipment. We could become a little modern there.

But in the winter when all of the cattle and calves came into our big barn, he wanted that scene to remain just the same as it had always been. Even though there were no longer milking cows and we were raising beef cattle, the animals still stood in stanchions with all of those cows having to be fed and bedded individually. The upper part of that barn

held many, many tons of loose hay that had to all be handled by fork and carried to the different animals. On the northeast corner of that barn stood a big silo. It was in the shade of the barn so the sun never hit it, and the silage froze along the edge from December 'til April, which meant that you had to climb up and chop and pick and throw it down and carry it to the cattle in a basket.

One of the first pieces of labor saving equipment I brought to that farm was the bushel and a half basket—a switch from the bushel.

We could not move snow with anything but a shovel, because the old tractors were not of any use in the winter. So we also had to keep a team of horses in the barn to pull the wagons or the bobsled through the snow. This all made the winters long and dreary for me, with endless chores seven days a week.

One of the ways my dad liked his retirement was for me to get out to the barn early in the morning and start feeding those cattle. Later, about 6:30 a.m., he would come out and help. Mainly he would visit with the animals and see that they were all fine, do what little work he wanted to do, and then we both would go to the house and have a good breakfast. After breakfast we would return to the barn, and I would spend the full day getting the silage out of the silo and getting the loose hay out of the haymow in preparation for the next day's feeding, and then doing the cleaning and bedding of the cattle. This was an ideal situation for him, but not necessarily for me.

This particular year a chicken, born totally out of season, found her way to the warm barn. She was a beautiful little hen, almost grown, jet black with white flecks on the end of the feathers. If there was ever a beauty contest for hens, she should have been in it. Because she was the only chicken in a barn full of cattle, she had to stake out her territory. At first she was in terror as baby calves ran after her up and down the alleys, and cows would bunt at her with their heads. Soon she learned how to get along, flying in the faces of those baby calves who were terrified and ran in the other direction, and pecking at

the noses of the cows if they would bother her. It wasn't long at all 'til she just fit right in with the group, and she became very much a character.

I started noticing, that as my dad was coming toward the barn, he always whistled. He had a wonderful, clear whistle trained from many hours of working alone in the fields. We would hear that clear whistle coming and then the creaking of the frosty hinges as that door opened on the horse barn to the west. The horse barn was always colder with only one team of horses standing in it, and in the darkness, Dad would always speak to them as he came through. Then the whistle would carry on into the main area of the barn where the cattle were standing.

Soon I noticed that this little hen would run toward the door when she heard the whistle, and my dad always greeted her in a loud voice. He would ask her how she was and if she'd had a good night's rest. Sometimes he would even bend down to pet her, but she would sort of dance away from the petting. She didn't think that was appropriate in their relationship. Then the two of them would go down the alleys together, greeting all the cattle and seeing that they were being well fed. That little hen would look up at him, and sometimes he would ask her kinda personal questions, like he was wondering if she'd ever thought about laying an egg. Mostly they just walked around together for they were good friends.

One day this little hen was just not herself. First he thought she was just out of sorts, and then he realized that she was getting ready to lay her first egg. He went over to a manger where calves were eating hay. This was before we started baling hay so it was piled high in loose, fluffy mounds. In that soft hay, my dad made a deep dark hole, because he knew that laying that first egg is a big job. That little hen was standing right beside him kinda puzzled at what he was doing. Then without any warning he scooped her up and put her into that dark hole he'd made into the hay. She popped right back out of that nest. She was indignant. She thought he had stretched

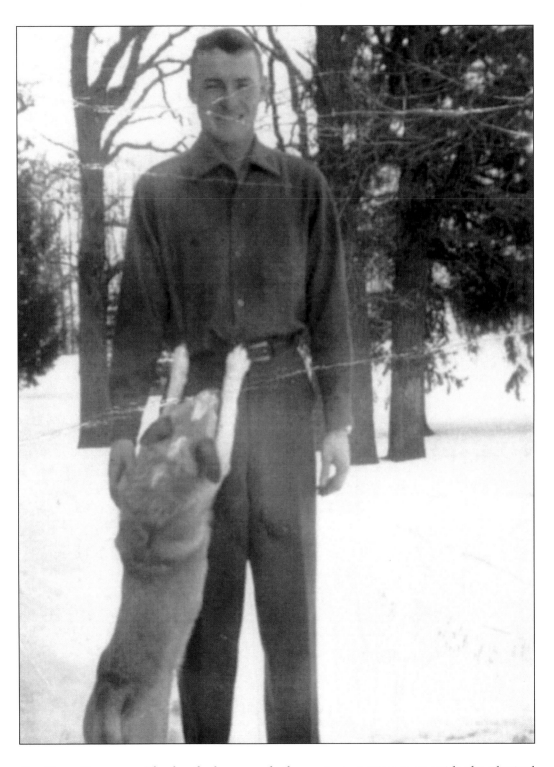

THE THIRD GENERATION. *The family farm needs the next generation to provide the physical strength and a new direction. Michael and Tiker are ready to take on that role.*

the bounds of their relationship. She was just ready to fly back out of that manger when it occurred to her that it was just the spot that she was looking for. She got back into that nest (he had been right all along), and she settled down to begin the job of laying that first egg.

He would check on her from time to time, and pretty soon she was standing up on the edge of that manger, cackling and celebrating that egg. He came over, and she cackled, and he congratulated her, and she cackled, and he laughed, and they had a little celebration right there together.

Later on he took that little egg to the house where he told my mother the story of that special little hen, and she fixed that egg for his lunch.

So morning after morning the situation was the same. The little hen would be there to greet him at the door, they would visit with everyone and do whatever work they needed to do, and later in the morning she would let him know that it was time to lay her egg. Then he would fix a nest for her. By now she would just hop right in there without any hesitation, and before long she would be up on the edge of the manger, cackling and announcing the new egg, and accepting his congratulations. Before long that egg would go off to the house for my dad's lunch.

One time while she was trying to lay her egg, the calves were eating that hay and tossing it around with their heads. She couldn't lay her egg in that situation, so she
hopped out of the nest and went right past me. She found Dad somewhere in the barn and let him know her need. Soon he was coming back with his long strides, with that little hen running beside him like a tattle tale. He chased the calves away and made her a new nest. She hopped up in it, and pretty soon was announcing there was a new egg.

My life has changed after all these years. That little hen and my dad are long gone. I now call myself a storyteller, and at times I tell my stories in retirement homes. I oftentimes see old men about the age of my dad when he was enjoying retirement by spending his days in the barn. They are sitting before me in clean clothes, and all their bodily needs are taken care of. But when I see their eyes, the life seems to be gone from them. I would long for them to have a big barn filled with animals that they loved and a little hen waiting at the door to greet them. And maybe later on in the morning, that little hen would jump up in the nest that they had made and lay a new fresh egg for lunch.

I think a home place is different than a house. A home place is a young person's introduction into life. It's connected with family and farm, where births and deaths are witnessed, and where children get to know baby animals as pets, knowing that some day these pets will go away to market. It's a place where children learn to be responsible and to know the wonderful feeling of being an irreplaceable part of a team. Along with the adults, children worry about the crops and the weather, and when the harvest is finally in, they all experience the wonderful feeling

CHAPTER 5
The Home Place

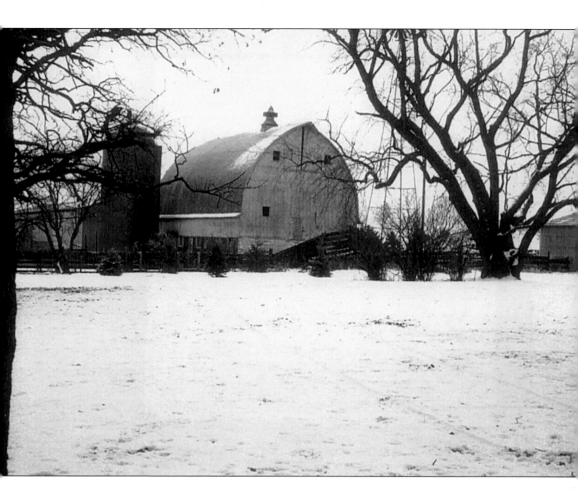

THE COTTER FARM SITE. The large barn, the silo, the cattle sheds, and cattle chute all indicate that raising livestock is a major part of this farm operation. The maple tree was only a sapling when it was twisted by the 1928 tornado.

of a job completed.

My memories of our farm in the early 30s were comprised of sounds and smells and sights. All farm yards in our part of Southern Minnesota had certain specific buildings around them, and almost the only difference was how much they were separated from the house.

The house where I was born was built in the 1880s. It was a two-story wood frame house that cost $1,000 to build, when many of the neighbors were still living in log cabins. Our home consisted of a huge kitchen with a wood cook stove and cupboards, and the Maytag washing machine with a gas engine sat by the back door. There was also a sink with no running water. The pump that reached down into the cistern did not work. The kitchen was a warm room in the winter and it seemed like my mother was always in it. It was also the place where everyone gathered.

Next to the kitchen was a dining room with built in cupboards and a big oak table with an Aladdin lamp in the middle of it. We always ate in the dining room. The phone with a crank and a dial hung on the wall near the front door.

The living room was a large room with a big Heatrola in it, and upholstered chairs and the big battery operated radio. From the living room you could go into the north porch. It ran the full length of the living room and it had its own entrance. A lot of fancy dinners were held there in the summer, but it was a great freezer in the winter. All the screens and storm windows had to be replaced every spring and fall. The parlor was a northwest room and was closed most of the winter. It had a big piano and straight backed chairs with upholstered backs. It had many rules for behavior—sit up straight, behave, for company only, not to play in, musty solemnness prevailed.

My parents slept in the only bedroom downstairs. There were three bedrooms upstairs. One had an alcove for a bathtub. The stovepipe came up by the bathtub and crossed over to the chimney providing a little heat for the bather. My sisters' bedroom had a grate in the floor where the heat, and the conversations, came up from the kitchen. The northwest room, the coldest room, was the boys' room. I remember going to bed with a flat iron wrapped in towels for heat. It was icy cold by morning.

Our house sat on a little knoll and was separated about 300 feet from the barn. That was considered a long distance at that time, and people who did not have their buildings close together were considered uppity and the farm site inefficient. The barn, the corncrib, the granary, the hog house, and the chicken house were all buildings that had to be visited regularly, and in the winter, a path had to be shoveled by hand to each one, so having them all grouped tightly together made a lot of sense.

We tried to maintain a lawn around our house, but it was pretty hopeless. With the old reel type lawnmower that pushed hard, the busy planting season, and the shortage of help, the grass usually got ahead of the lawn mower. Many of our neighbors' farms had little or no lawns at all. There was usually a little area around the house where someone tried to grow some flowers, but most of the time if the farm raised pigs, they overflowed to the lawn. If chickens were the main project, the lawn became a place for feathers and short grass with chickens always present.

If you drove on our farm early on a summer morning, the cows would be coming out of the barn having just been milked. The tall milk cans or the short squatty cream cans were lined up outside the barn ready for their trip to town. The sounds from a short distance away were of that ritual known as morning chores—baby pigs being fed or waiting to be fed, draft horses standing in the barn eating their morning grain and being harnessed for the day's work, and the chickens being tended by the woman of the house or the kids.

The men who had been doing the chores would pause for a large breakfast of meat and eggs, fried potatoes and bread, milk and coffee. Then they would head for the fields

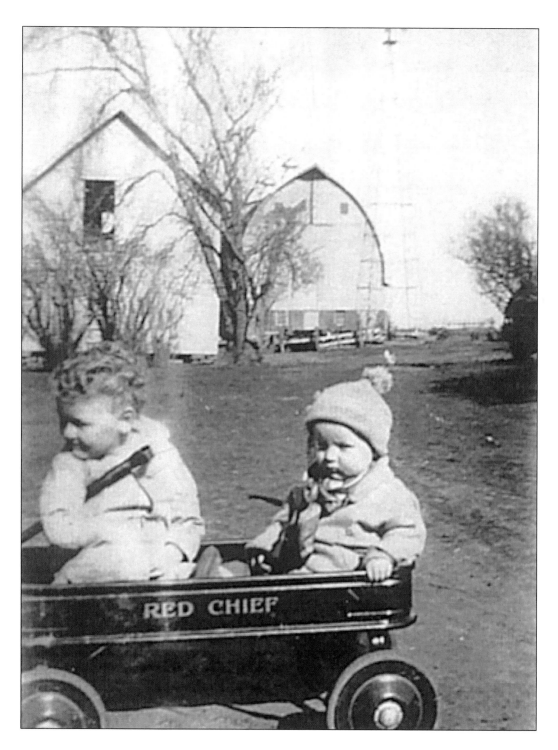

DICK AND MICHAEL IN THEIR RED WAGON. Boyhood on the farm is a carefree time—a time of absorbing the rhythm of the seasons, the people, the animals, and the land that are all a part of the home place.

A LONG DRIVEWAY. When the farm building site was first considered, if possible, it was placed on higher ground. While good drainage was the main reason, it often meant the buildings were set back a distance from the road requiring a long driveway, difficult to maintain in the winter.

to tend the crops with their various horses and equipment. The old men and the kids, sorta considered the unlucky ones, stayed behind to clean the barns and the pig houses and to do other various chores so that the farm could start the next day the same way.

Our barn was ninety feet long, round roofed, and painted gold. I don't know why my dad chose that color. The 65-foot windmill tower and a large round wooden water tank stood on one end of the barn. There was always the sound of water being pumped, and the tank served as a reservoir that kept our water supply in balance for the two separate yard pens. The windmill was always running.

When you entered the west end of the barn, there were stalls for twelve horses. When they were out in the field, the pleasant smell of horses stayed there in the hay. In the summer, the barn always seemed to be cool. The east end of the barn contained two ten-stall rows of stanchions where the milk cows were penned individually. The cement feed mangers ran the length of those rows. There were pens for calves along the side of the barn and across the east end. Above all of this was a large hay mow with loose hay, and the breeze coming down from the two open hay chutes carried the sweet smell of that hay and mingled it with the other odors.

A silo, 16 feet in diameter and 40 feet tall, stood on the north side of the barn connected by a little room called a silo room. That pungent odor of fermented silage carried into the barn and joined the other odors. A litter carrier track ran from the horse barn, behind the cows, through the pens and exited on the

east end of the barn. There the manure could either be emptied into a spreader or stored on a large pile to be hauled to the field later. The east end of the barn was the furthest point from the house. Farmers were judged by the distance the manure pile was from the house.

During haying, the sweet fresh odor of new mown hay dominated the farm, during threshing, the odor of the new straw pile and the fresh smell of ripening grain, and during silo filling, it was the smell of fresh cut corn and the fermenting.

I was a little boy during the Depression years, and it seemed to me the whole world must be moving, for sometimes on summer days, whole families would come to our farm. Mostly we would see lean, gaunt, desperate men coming across the yard, many of them from the railroad tracks three miles away, some with their faces beat purple from the cinders from riding underneath the rail car. It was known as riding the rods. It was not your first class fare.

I can still see them walking across our yard, and I still feel my fear when I heard them say, "Hey, Kid, is your Ma home? Is your Pa home? Would you tell 'em I ain't et in two days?" The policy on our farm was that my mother would always feed them and my dad would always find work for them to do. Some people called them hobos, and some called them bums, but we called them drifters. Some worked for a few hours, some for days, and some stayed on for many years.

At that time, before electricity on the farm, about 200-feet away from our house there was a small building called the bunkhouse. These men slept there, but they ate with us. These were the people who worked on our farm at that time. They traded their muscle for board and room and a little spending money.

At this time in history, farmers did not leave their farms much. Families spent their entire lives working and being part of that farm. We didn't get much outside entertainment.

In the summer after the evening meal had been eaten and the milking had been finished, these drifters would gather under the windmill just as darkness was falling. The windmill would be running quietly in the evening breeze, and you could hear the kussshhh-kussshhh sound of water being dumped into a long pipe and across the milk cans that were sitting in the stock tank with their covers loose. The mosquitoes buzzed and the smell of warm milk was heavy in the air. Those drifters gathered and shared memories.

For me, a little boy, those many drifters who passed through during those Depression years opened up a whole world with their stories. I'll tell you about a couple of them.

There was John, a strongly built man with white hair. Then I called him an old man, now I'd call him middle-aged. His story took place in the late 1800s when he lived on a farm in Southeastern Iowa, where the farms are small and the land is hilly. John grew to manhood physically strong but socially very awkward, particularly with the opposite sex. This was not uncommon at that time. He went to a small, remote, country school, where kids were limited in their social contacts.

The summer when John was 16, there was a girl who lived a couple miles from them, but he only saw her on Sunday mornings, when she and her mom drove by with the horse and buggy on the way to church. John thought she was the most beautiful girl he'd ever seen. She always wore a white dress, and he learned her name was Wilda. John waited each Sunday morning for her to go by. He hid himself behind a tree or by a building, so he could remain unnoticed while he watched her pass. It seemed like there would never be any solution to this problem of John pining away for Wilda, but one day he had a stroke of luck.

The horse that Wilda's mom was driving balked right in front of their driveway. When that balky horse planted his feet firmly and would not move, John saw an opportunity. He didn't know much about women, but he knew a lot about balky horses. He grabbed an armful of hay from the barn and raced down the driveway. He threw the hay under the

horse, took a match out of his pocket, lit it, and threw that in the hay. Then he looked at the two startled women. In an instant the flame sprang up, and so did the horse. He gave one big leap and stopped again. The fire was now under the buggy.

After all these years, I can still see John's face. His eyes were large. He was not under that windmill now. He was the young man at the end of his driveway. He said, "By God, then I had something." But he was a man of action and a strong man, so he grabbed the wheels of the buggy and rolled it up on its side. As he tried to brush the flames off the floor of the buggy where it was burning, it got away from him and rolled into the ditch, along with Wilda and her mom and Wilda's white dress.

Then the story seemed to end, and one of the men under the windmill said, "John, whatever happened to Wilda?" John's face got sad then, he really hadn't intended to tell any more. He said, "By God, I don't know. Don't know what happened to them. You know," he said, "they started driving another road to church."

One of the other men who lived in that bunkhouse worked on our farm many years. His name was Al. Al had beautiful white hair and a crippled leg. My sisters didn't like him the way I liked him, for he'd sit at the table and pick his teeth with his dinner fork. My sisters always made sure that he got the same fork at every meal. Because Al was so old and crippled, and because I was so young, we couldn't work in the fields with the other men. We had to do chores.

In the wintertime, after the noon meal had been eaten, we would give hay to the cows, and then Al would make up a pile of hay under the chute. Because that hay chute led into the upper loft, the smell of summer was always in the air. In that pile of hay, sometimes Al would take a little nap, and he would tell me endless stories. He'd tell about the time when he'd been a cowboy, and all the marvelous things he'd done, and all the people he knew. And more than that, Al and I would dream together.

This was in a time, when our whole farm was run by draft horses. Al told me that if I would train some of the baby calves that were running around the barn, we could make them into a fine team of oxen. He said a team of oxen could pull more than any of the horses on the farm. He also told me that if I would go to work and train them, he would make me a set of harnesses for them. I couldn't have been more excited.

We selected two calves, named them Buck and Jerry, and worked with them for several weeks. But when we tried to hitch them together with those cobbled up, home made harnesses, the calves tore them apart, and the project kind of ended.

Al's stories helped me dream and dream. And when I told my dad that Al had been a cowboy once and had ridden the range and roped and branded cattle, he sorta dashed cold water on my imagination by saying, "That damn fool probably hasn't been west of Freeborn County." Now Freeborn County is the west edge of our farm, but I think mostly my dad was upset because Al was taking an afternoon nap.

I don't remember when Al drifted away. I know I was about in 5th grade when my mother read in a newspaper that Al had died in a small neighboring town. I know she considered taking me out of school to go to his funeral, but she didn't. When she got to that little funeral home, it was just she and the undertaker and a closed casket. She asked the undertaker to open the casket so she could see if it was our Al. There was Al with his beautiful white hair, so she told the undertaker how he'd been my friend, how he'd helped me train a team of oxen, and how he'd helped my imagination with his stories. And that's all the funeral there was for Al.

I'd never seen my mother cry before. She always said if you had your faith to guide you and your family was in good health, there was "no need for that kind of foolishness." But that night she did cry, and she said how families need to stick together and watch out for one another. She said no man should die alone.

After Morning Milking. Before the Second World War ended, farms in Southern Minnesota had many types of livestock. Daily chores consisted of morning and evening care of the animals. Dairy cows demanded the most work but provided a regular, monthly milk check.

But Al was a drifter. Drifters always told of the places they'd been and the things they'd done, but they seldom ever mentioned the family they'd come from or their home.

Many years later in another season of my life, when the machine age was rapidly overtaking agriculture, I had insisted, and my 75-year-old dad agreed, we must get rid of our draft horses. The evening before they were to be loaded, twenty horses were driven in from the pasture. I remember how the earth shook as they galloped by—those animals that weighed a ton each, animals that had been the pride and backbone of our farm.

It was our agreement that we would keep one team, because my dad said, "Every farm needs one team." The rest were to leave. The

horses, all with names like Dan and Tillie, ranged between young unbroken four and five year olds and old work-worn horses that had not worked for several years. The hardest part for me was knowing that these horses, who had pulled a cultivator, or a harrow, or hay into the barn, or a wagon for feeding cattle, or cars from the ditches, were going to go to a mink farm—their flesh to be used for mink feed. They had no value in the machine emerging agriculture.

The next morning when the trucks came, my dad would not come out of the house. I'd never known him to quit a job, but that day he did not show up. He did not see those frightened animals loaded into a truck for the first time in their lives, and he did not hear

their big hooves slamming against the side of the truck or their squeals and whinnies as they were driven away. Our horses were born on the farm, and they died there, and in my dad's great pride in the herd of twenty beautiful horses, he hadn't wanted to notice that time was passing us by. We seldom talked about that day. For me it has become another almost forgotten memory of the home place.

When I think about the home place, my first thought is, "It just can't be sold." The message I received while I was growing up was, "It always has to be trusted to the future generations." The home place held memories for the generations before me and it does for my family today. In some ways it seems like the home place is like the land itself. It can never be sold and never be owned. We are just stewards there for a while. The history and the memories are much more powerful than the individual himself.

I am the third generation on our Minnesota farm. It has been in existence for 125 years, so these are long generations. I'm caught between the history and the future of this farm, because I know the end of my watch is drawing near. In each of these generations, an event or combination of events happened where the farm could have been lost, and I'd like to tell you the stories.

Maurice Cotter, my grandfather, came from Ireland about 1850 on a sailing ship with his older brothers and a widowed mother. They eventually found their way by covered wagon to a settlement about five miles from where our farm is now. In the early 1870s, when grandfather was about twenty-five, he married Catherine Hoban who lived in the same area. He was expecting that they would have the farm where he lived, but there was some sort of a misunderstanding that made him very unhappy.

They left the community where they had settled and moved 5-miles away. This was a drastic move at that time of poor roads or no roads. They crossed into another county, and then bought two hundred forty acres of land from the railroad. This became our original home farm. My dad was the second child in the family, and they moved to this farm right after he was born. My grandfather built a granary on the farm, and then walking behind a breaking plow pulled by oxen, he broke that prairie sod and planted wheat.

He was a pioneer type of man standing 6 feet tall, wearing a mustache, and weighing over 200 pounds. My dad always used to comment that grandfather had such broad wrists, that he had watched him set a 300-pound barrel of salt out of a wagon. Grandfather was made for the job he had to do.

One of my dad's earliest memories was of living in that granary where the wheat was stored above and the family lived below. He used to say how that wheat was cool and wonderful to sleep on in the summer, but in the winter they would have to move down. He just couldn't get warm up there.

The first winter they lived there was very severe. They had some livestock but very little shelter for them, and back then if your cows and pigs and horses didn't live, then neither did you. The animals were necessary for survival. My dad would often hear grandfather tell about a stormy winter day when the snow piled high, and he couldn't feed his animals and couldn't protect them. He came into that little granary house, sat down by the fire and began to cry, for it seemed like there was no way they could survive.

The story is told of how his wife Catherine, with two small children and maybe a third one coming, really lit into him. She said, "Look at you—a big, strong man, your whole life before you, a young family, and your health—sitting here crying." She took the broom and began hitting him with it. As my dad said many times, grandfather went out into the storm and back to work, and never came back in to feel sorry for himself. Grandfather often said at gatherings how it was the best thing Kate ever did for him, though she never liked to hear the story. From that beginning, they became fixtures in the community and helped to build churches and schools.

One of the stories my dad used to tell is

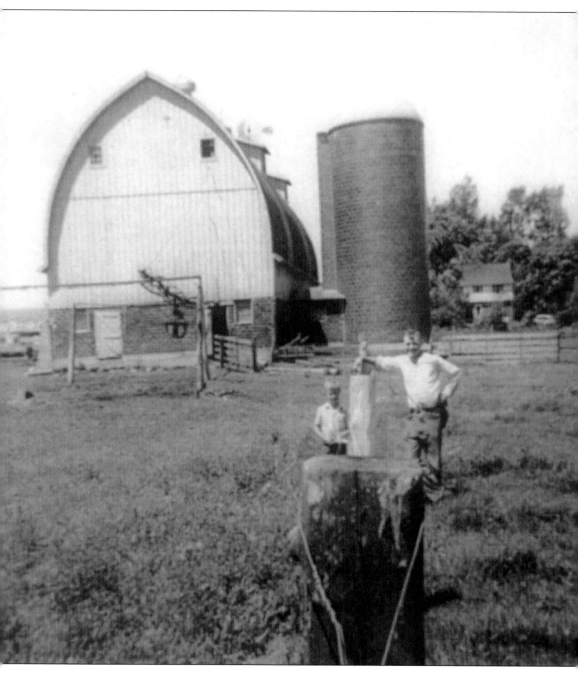

BUILDING FENCES. *Work on the farm was never ending, and maintaining pens for all of the animals required a variety of fencing—a job that most farm kids hated.*

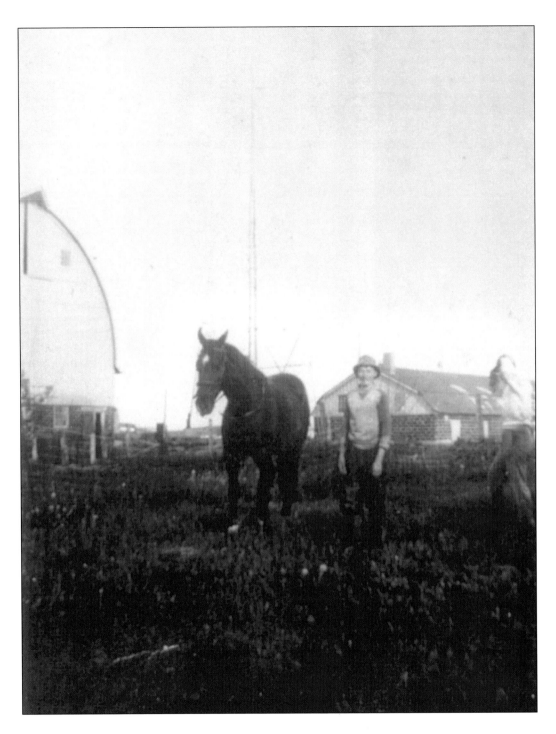

A Horse of His Own. Michael was 12 years old when he got a riding horse. He named him Thunder. Thunder helped to bring the draft horses in from the pasture in the morning even though they didn't want to work, and he could round up a wild cow. He helped Michael connect with the world outside of their farm.

how grandfather would haul his wheat to Winona where there was either a much better market or the only market. Winona is on the Mississippi River, a hundred miles east of us. There is rough terrain between our farm and the Mississippi, and I can't imagine traveling it with a team of horses and a wagon. I would hear my dad talk about the nights when he was a little boy. There would be an oil lamp in the center of the table, and he would watch his father, night after night,
rubbing bear grease into his cowhide workboots. They didn't have overshoes in those days, so they had to make their boots waterproof.

There was always a sense of fear in the air as he got ready for one of those journeys, because they knew that he would be gone for weeks. Grandfather had to try to anticipate the weather, and then find shelter and get out of the storms when they hit. Sometimes he would be caught in such a storm that he'd have to give a goodly portion of the money he got for the wheat to the people who sheltered him. His family had no contact with him until he got back.

The one story I remember that was told over and over is of the time the horses were crossing a river. I don't know if they were crossing on ice or the river was swollen, but something happened and the wagon was swept downstream with the current. The horses were being pulled under by the wagon that they were hitched to. My grandfather jumped into the water to try to save his horses. I guess he was an excellent swimmer having spent his boyhood off the coast of Ireland. As the wagon was being swept downstream, he somehow was able to free those struggling horses and get them swimming towards shore. The wagon of wheat floated downstream until it hit a tree that was reaching out into the water. Grandfather was able to get a rope hooked to the wagon, get the horses down on the bank and pull the wagon to shore. It was almost a superhuman effort. Equally challenging was the process of drying his clothes on a cold day with no shelter. I don't remember ever

hearing of him making another trip.

That experience had frightened everyone, but when he talked about what made his farm prosper, he only told the story of Catherine— how she drove him out into the storm with a broom, and reminded him that he had more to do than to feel sorry for himself. He always ended it by saying, "It was the best thing she ever did for me."

He knew he needed more land when he got going, and there was an eighty acres across the road from him. He heard it was owned by a preacher, name of Preacher Reynolds, who traveled about burying and marrying people. After grandfather rented that eighty for pasture for a couple of years, one day he took the big trip to the courthouse, to see how his taxes compared with those of Preacher Reynolds. He found out that land was not owned by the preacher. It was owned by the railroad. He bought that eighty acres that day, and drove way out in the country where the preacher lived on a little place. Grandfather asked if he could see the deed to the property before he paid his rent. The preacher and his wife were both pulling out drawers and looking high and low in that house when my grandfather left, for he had the deed in his pocket. Preacher Reynolds was not a popular name in our household for many years. That was how grandfather got that 80. Before he died, he accumulated more than 500 acres.

The second person in charge of that farm was Richard Cotter, my dad. Richard was born into more security although he was born in 1876, the time the farm started. I think he maybe enjoyed life more than some, always with quite good health and a sense of humor. He remained a bachelor until he was 37. When my mother would get mad at him, she would say, "A bachelor thinks he is a thing of beauty and a boy forever."

It was not uncommon at that time for Irish to stay single for a long time, but when my dad did marry, he had quite a few children. My mother was twelve years younger, and their first six children were daughters. At this time in history, it was terribly important

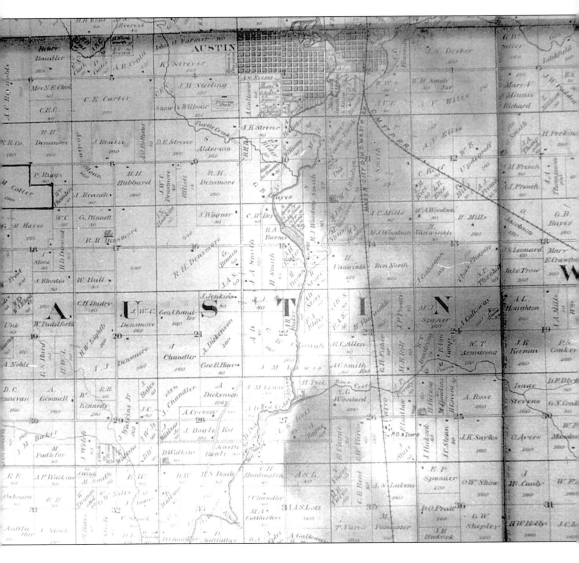

Mower County Plat Map, 1889. Plat books are an accurate record of farm locations. This map shows the Cotter farm in Austin Township, southwest of the county seat, and bordering Freeborn County.

to have sons on farms because of the hard physical labor. My father was a hard worker and seemed to love animals and livestock. There were always people around that farm and a lot of work to do.

He did not buy land like his father had. Instead he bought stocks and bonds with the money he saved, and also I think he had some sort of a plan to take care of his family if he would not be able to work. All of his daughters and his first son were college educated. That son, the seventh child, was born in 1928.

Two major things happened that year. The first son was born in February, and in August a killer tornado came through and totally destroyed the farm buildings, leaving only a badly shaken house. Many of the trees that formed the windbreak around it were down. The fences and the buildings to store grain were all down. The crops were pretty well ruined. I know there was some discussion on whether or not to keep going. Dad had this little boy that was six months old, and that was the reason he gave for rebuilding.

When the family decided to rebuild, he went at it in his usual way. He did not believe in borrowing money, so he planned to sell all his stocks and bonds, use what little insurance they had, and sell enough livestock to pay for it all.

The banker heard about his plan and drove out to visit. I don't know if he came by horse and buggy or a car, because both were used at that time. He stayed for supper and talked to my parents, 'cause that was the custom then. He told my father that because of those wonderful stocks and bonds that were all paying a high rate of interest, that he would loan him the $50,000 needed to rebuild the farm buildings. He would loan it at a lower rate than dad was getting for his bonds, and the way he said it was, "Dick, you'll build this whole farm up for nothing." After he had made his point and finished his meal, he left and my parents continued the discussion.

My mother said, "He's a well educated man, and we probably should listen to him."

My dad said, "Those damn bankers are all alike, only interested in money." And in his usual way, he did things exactly as he planned, selling almost all of the stocks and bonds and some livestock, getting all the lumber and material brought in by train, hauling much of it out to the farm, and hiring the carpenters.

The buildings were just being built when the Crash of '29 happened. What little stock he had saved was absolutely worthless, as was much of everything else, because this was the beginning of the Great Depression.

I never remember that story being told much—the part about mother wanting to listen to the banker. That was a part she didn't like.

As I think about it, that one decision, which was certainly not considered wise at the time, was probably a big reason why my sisters and brother were able to go to college and why we are still on the farm. During the Depression, even farmers that had a $1,000 against them were unable to pay it back, and they would end up losing their farms. We endured the Depression debt free, although we worked hard and were thrifty, we were very much a part of the church and the community.

So much of it goes back to that one decision.

The only land my dad bought was a rolling pastureland in the hills 7 miles from home. It was always considered a romantic place, and we called it the North Farm. He got it in the late 1800s in an unusual way. He had a kind of wild cousin about his own age. That side of the family loved gambling, and his cousin Martin was the very best. Austin, Minnesota, was not big enough to handle his ability, so he went by train to Saint Paul where he met professional gamblers.

Before too long, Martin found that if he didn't pay his gambling debt, he wasn't going to be alive, so with the stipulation that the story never be told, he sold his dowry to my dad, 100 acres of pastureland.

Some secrets are too big to keep, and when Martin's father realized that he had sold his dowry to pay off a gambling debt, the two families stopped speaking.

This land enabled us to have a large cattle operation. It had its own running water and we kept our cows there in the summer.

My time of responsibility on the farm began in the 1950s. With my dad seventy-three years old when I graduated from high school, I got to be in charge at an early age. Much of the 50s was spent in a struggle with the old and the new ways, and progress came very slowly. This was the end of the era of horsepower and very simple machinery.

In the 60s, my wife and I and our young family built a new home, and with the encouragement and support of my brother who was now a lawyer, we moved into a much more modern era—a time of bigger machinery and the addition of chemicals into agriculture. We more than doubled the size of the farm, and it prospered, expanding not only in acreage but in debt. Equipment grew larger and more sophisticated and many new chemicals were used. Nation-wide the farm expansion was in full bloom. The popular theory at the time was, "There is only so much land and there is no more. When it's gone, it's gone. It will always be more valuable. Inflation was carrying the value instead of profits, and many farms were worth well over $1 million.

When the world markets dried up, and land dropped to a third of its earlier value, prosperous farms found themselves totally bankrupt. Banks were pulling loans, and they were hauling machinery away and selling it at public auction. We moved into an era that later became known as the Farm Crisis. It was a frightening time for all farmers, as many solid family farms were going down. The papers were full of foreclosure notices and families were falling apart.

It was at this time that my wife filed for divorce, and my lifetime of financial security turned upside down. Like the blizzard and the devastating loss of his livestock in my grandfather's time, and the tornado and the Depression in my dad's time, the farm crisis combined with the divorce made me totally vulnerable to outside forces that were beyond my control. During the months that followed, many people stepped forward to help, but it seemed like others were there to try to bring me down.

By good luck and faith and some heavy losses, I hung on, and I was able to hold much of the farm together. There were some real good people that stuck with me and I was eventually able to pay them, but there were times that the farm was right on the brink of disaster. As I look back, it was like a ten year chunk came right out of my life, and a glance in the mirror showed that I got awfully old looking in those years.

As I reflect, it seems that every generation has had a chance to lose the farm, and it was not saved generally by following the popular thinking of the time. It was like some kind of wisdom was pulled from real deep, wisdom that only looked wise as you looked back at it through history.

I think my time will have to be judged by others as I have judged the actions of my grandfather and father. As the farm goes on into the unknown, as it gets ready to change hands again, we almost know that the next caretaker will have that moment when a disaster just might bring it down.

This farm has provided our family with stability and prosperity since 1876. I have to hope the next generation will have the wisdom to keep our farm on into the future.

MICHAEL WITH HIS PARENTS, ROSE AND RICHARD. The expected role of a son meant living at home and lightening the workload of his father. This allowed for a comfortable retirement for the parents and a gradual shift of responsibility to the next generation.

Nurtured by Three Generations. Over the past years, the methods of farming have changed, but the purpose remains the same. This landscape portrays the story of an abundant harvest and

land lying fallow in anticipation of spring planting.

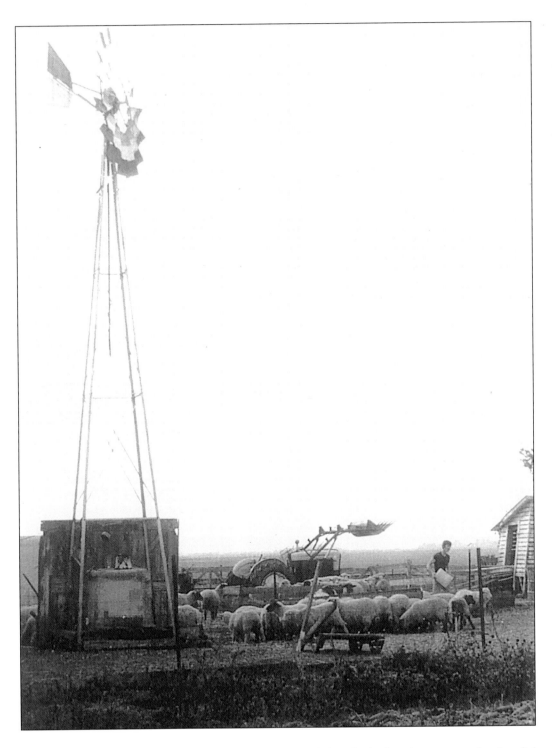

Hydraulic Power. In the 1950s manufacturers claimed that the hydraulic manure loader did more to keep boys on the farm than any other machine. It enabled the tractor to do the heavy lifting that was done manually by previous generations.

*A **Photo Opportunity**. At a family wedding, the new tractor was brought out to show the city guests how the farm was modernizing. The new rubber tires allowed it to be run on the grass without causing damage to the lawn.*